The Craftsman's Survival Manual

THE CREATIVE HANDCRAFTS SERIES

GEORGE & NANCY WETTLAUFER

The Craftsman's Survival Manual

MAKING A FULL-OR PART-TIME LIVING FROM YOUR CRAFT

A SPECTRUM BOOK

PRENTICE-HALL, INC., ENGLEWOOD CLIFFS, NEW JERSEY

Library of Congress Cataloging in Publication Data

Wettlaufer, George.
 The craftsman's survival manual.

 (The Creative handcrafts series) (A Spectrum Book)
 Bibliography: p.
 1. Artisans—United States—Handbooks, manuals,
etc. 2. Handicraft—United States—Handbooks,
manuals, etc. I. Wettlaufer, Nancy, joint author.
II. Title.
HD2346.U5W47 658'.91'74550973 74-12281
ISBN 0-13-188789-0
ISBN 0-13-188771-8 (pbk.)

Line drawings by Bill Haust

Printed in the United States of America

Prentice-Hall International, Inc. (*London*)
Prentice-Hall of Australia Pty., Ltd. (*Sydney*)
Prentice-Hall of Canada, Ltd. (*Toronto*)
Prentice-Hall of India Private Limited (*New Delhi*)
Prentice-Hall of Japan, Inc. (*Tokyo*)

Contents

Preface

We are craftsmen living off our craft, who have tried most of the suggestions and techniques presented in this book. We have learned marketing, bookkeeping, and business from our own experiences, with some help from professionals. This book is intended to give individual craftsmen some practical business and marketing ideas.

We are a two-person team with a family. We hire no one except part-time students to do some clay mixing, packing, etc., in return for learning. Our pottery is made by us, not by a team of potters working for us. It is our opinion that the true definition and satisfaction of handcrafts starts to break down if more than one person or team is responsible for designing and working through an object. We are, therefore, not talking about handcraft factories, although some of the same principles are applicable.

The individual craftsman's goal should be excellence in design combined with efficiency in production and marketing. It is the business and marketing aspect of this goal that we intend to present in this book. Many craftsmen who have no training (and often not much interest) in this field need to acquire some of these basic skills for survival. This is largely a matter of common sense and experience and is not as difficult or painful as many think. The following material is drawn

mostly from our experiences and observations as craftsmen trying to survive

from our craft alone—and so far, happily succeeding. Although we are potters, these ideas are applicable to craftsmen in all media.

If you have already survived the first few years and developed your own methods, you may not need to read this book—you probably could have written it. On the other hand, if you are thinking about starting out, just starting out, or having specific problems, perhaps some of our suggestions will be helpful. And although this is not written specifically for someone running a craft shop or managing a show, there are many useful suggestions for both, as well as for students and hobby craftsmen selling some of their work.

We have deliberately not defined the word *craftsman;* if you are a craftsman you know it. You also know what type you are—traditional artisan, artist-craftsman, hobby-craftsman, production-craftsman, professional-craftsman, etc. We are directing this book less to the "craft-worker" who makes items that are usually designed and marketed by someone else than to the professional artist-craftsman who designs, executes, and sells his work himself. The designation "professional" most often means simply "someone who makes his living at his craft" as opposed to the "amateur," who works at a craft merely for enjoyment or for a supplement to his income. Professionalism, in our view, should also encompass a set of values and attitudes shared by other professionals, such as lawyers, teachers, doctors, and engineers.

The question of value ought to be brought up at the outset. Many people make things that have value to them; but, before you think about how to go about selling your work, you must ask youself seriously whether your work has sufficient value to others to warrant your selling it. The mere fact that it is made by hand does not in itself give value to something. This is a very subjective question, and it is up to the individual craftsman (not a jury or a standards committee) to try to determine honestly for himself.

There is a paradox in writing a book on marketing methods when we believe them to be of secondary importance. Making money is important only in that it is necessary to enable one to keep doing what he wants to do—create beautiful things and live his life freely and with meaning. Perspective should be maintained in reading the book, for, as important as business and marketing skills are, they are always subordinate to the craftsman's integrity as a craftsman and as a person.

It may be helpful, in the definition of problems, to point out that most craftsmen are telescoping at least two activities into one. They are, in most cases, both manufacturers and sellers of their wares. It is possible that if one's interests and strengths lie primarily in one of these areas, he should concentrate on that half of the process and leave the other half to someone else. In reality, however, most craftsmen end up taking part in the execution as well as the selling of their work.

There are certain accepted norms in the business world that are not really applicable to the craft world. One is that growth is either inevitable or at least desirable. Most craftsmen prefer to "think small." It is also a rare situation in the normal 8 to 5 business community when a person works full-time for half salary. Many craftsmen are working in pairs because they would be unable to support themselves or a family working as individuals. Another accepted premise of the

"straight" world is that one works during the week and enjoys life on vacations or weekends. Craftsmen try to avoid this type of schizophrenia—work and re-creation become one and the same and occupy seven days of most weeks. Of course, your schedule is your own, and you can take some time off whenever you please, not when you have to.

Another rewarding aspect of the craft world, rarely present in the business world, is that one can do business with people he likes. Because you are dealing in limited quantities, you can select a few quality shops whose owners you like and want to see survive and who in turn like you, share some of your values, and want to help you survive.

We prefer to stay away from impersonal selling, such as through department stores, large wholesale shows, catalogs, mail-order, firms, sales agents, etc. These are all available to the craftsman, but direct contact with either the buyer or the small shop-owner who sells your work always seems much more rewarding.

We also feel that nobody should take anybody else's advice verbatim—including our own. We are trying to describe areas you should be aware of, not necessarily specific problems with specific solutions. You will have to define your problems yourself, but once you can do this, you are usually well on the way to solving them. Hopefully, we can provide you with some tools to make this easier.

For this reason we also list sources in the Bibliography that have been useful to us so that you can consult them when you need to. Books, periodicals, and organizations do exist which can be useful to all craftsmen. Specific ones also exist in each media, which you can discover for yourself by looking through the general information. Other craftsmen can be a great help as well.

Many people are attracted by the romantic idea of returning to the simple life. But, as Gene Shallit remarked at the conclusion of a *Today* show, "paradise takes work." Survival in "paradise" is also dependent on a frame of mind—the craftsman must see himself not only as a craftsman but also as a small business-man, and he must accept and enjoy the challenge that this presents.

Acknowledgements

Our thanks to the following people, who shared their time and experience in marketing crafts with us:

Susan Bowers, artist and former owner of the Studio Gallery, Webster, N.Y.

Barbara Brabec, editor, *Artisan Crafts* magazine

Mildred Burgess, artist and director, Art Mart, a Christmas consignment shop for the Allied Artists of Syracuse

Pam Carson, director, Philadelphia-Boston Flea Markets and other major shows

Marie Cole, artist and former manager, Everson Museum Sales Gallery, Syracuse, N.Y.

Barbara Cowles, co-owner of Shop One, Rochester, N.Y.

Jean Delius, silver craftsman and teacher at State University of New York, Oswego; trustee, the American Crafts Council

Michael Higgins, glass craftsman and marketing columnist for *Craft/Midwest*

Rudy Kowalzyk, leather craftsman and director, American Crafts Expo, Farmington, Conn.; show-owner and craftsman

xi Ron McKnie, craft-marketing teacher, Sheridan College, Ontario, Canada

xii

Acknowledgements

Bob Turner, potter and teacher, Alfred University, N.Y.

Merle Walker, textile craftsman, director, League of New Hampshire Craftsmen, former league shop manager; representative to American Crafts Council

And all our craftsmen friends.

*We don't need more things in this world
—we need people to live
with enjoyment and fulfillment.*

—BOB TURNER
Professor of Ceramic Art
Alfred University

The Craftsman's Survival Manual

Getting Started

How one starts earning a living from a craft depends partially on what he was doing before becoming a professional craftsman. Many go from student or teacher to full-time craftsman; in a way, this is the simplest and most direct course.

In our own case, our craft was a hobby that we were developing for our own pleasure and satisfaction. We only sold a few pots to friends to cover the cost of our materials. Circumstances gradually culminated in George's catching "mono" and quitting his job as an engineer—in time for the summer show circuit.

The following are questions we explored and things we did (or should have done) during the six-month transition between accepting our first dollar for a pot and severing all financial ties with the so-called "establishment." For those who like to think of this as "dropping out," let us add that we have never worked so hard in our lives.

Because we are a husband-wife team, some of our suggestions may have to be reevaluated by the individual craftsman working alone; basically, however, the same pointers should apply to both.

1

ASK YOURSELF SOME BASIC QUESTIONS

First of all, why do you want to make a living as a craftsman? Do you find the idea of earning your own living a challenge? Is the business aspect of selling your own work to put food on your table as exciting (or almost as exciting) as doing your actual craft? Perhaps what appeals to you is the idea of working with your hands and mind together—designing and carrying through an item from start to finish—the idea of completeness in an otherwise fragmented world.

Whatever your reasons, are you willing to become "commercial" in the sense of producing items in a repetitive fashion as well as adapting your work some- what to the demands of the market? If you are an artist, can you redefine yourself as a craftsman? This may require too great a compromise to make survival as a producing craftsman worthwhile. You will be making things with your hands, hopefully of a very high quality, but your primary goal will not be to create works of art.

Can you develop a thick skin for the purpose of selling your work to the public or to shops? Many may not appreciate or admire what you are trying to do. The necessary detachment and objectivity are often difficult.

Are you good enough technically at your craft? Mediocre craftsmen not only run the probable risk of failure, they also harm the craft market for others. The above questions apply to students going directly into crafts as a living as well as people leaving established jobs to become craftsmen. If you are one of the latter you will want to ask yourself a few more things.

Can you become accustomed to managing money that comes in at irregular intervals and get off the weekly paycheck habit—if you were ever on it? Will you feel inferior to those around you if your income is lower and you can't afford certain conveniences, luxuries, or entertainment? Be very honest with yourself— psychological survival is as important as financial survival. We are talking about "A Life as well as a Living," as do Helen & Scott Nearing in their preface to *Living the Good Life.* * This is what makes it as important a decision as it is. If you never were an avid consumer, had many time payments, hired many baby- sitters, or entertained a lot, the transition will be much easier.

If you are a husband-wife team, can you work together without undue stress as well as simply live with each other twenty four hours a day? Even in the best of relationships this adjustment may be difficult. For us, the rewards have far outweighed the problems, but not everybody can or should try it. If you are to succeed, both partners must be seriously committed to the idea.

Living the Good Life—How to Live Sanely and Simply in a Troubled World (New York: Schocken, 1970), xix. The Nearings mention Chapter XII of their *Maple Sugar Book,* "A Life as Well as a Living."

ADVICE FROM BUSINESSMEN

According to the authors of *How to Organize and Operate a Small Business,* *
"the principles of business have been developed over the years in terms of plain
common sense and therefore are not difficult to understand. . . . Knowing what
to do is far different than knowing how to do it. Still harder is to do it the best
way. The farmer who wrote the Department of Agriculture, 'Please quit sending
me more bulletins, I'm not farming half as well as I know how now,' is a case in
point."

Most successful small businesses were started by people who were successful
but unhappy working for someone else, and were willing to gamble their futures
on their own talents. These are people who are happy with the size of their
businesses as they are—they don't want to lose many of the benefits they cherish
so much.

Here is some advice from "successful" small businessmen that may be helpful
to the survival of craftsmen:

> Accumulate enough capital before you start.
> Be prepared and have money set aside for the unexpected.
> Be prepared for long hours. It takes twice the time you think it will take.

There is a strong probability, according to the business books, that the "be-
ginning independent" will make one serious error in judgment during the first
year. (They don't list any one error.) Most books on starting your own business
stress certain personality traits as very important to survival. Some of these are
initiative, responsibility, organizing ability, perseverance, decisiveness, physical
energy, etc. They ask whether you are a self-starter and can work without
somebody telling you what to do. We've also discovered that you need to be able
to *stop* working as well. This can be equally as hard, because there is always
something more to do.

TALK TO PEOPLE; DO SOME BASIC RESEARCH

Talk to some full-time craftsmen, visit their studios, work for one if at all
possible—partly to learn the craft and partly to learn the organization. (The few
months that Nancy worked for a studio potter mixing glazes, packing pots, etc.,
turned out to be much more valuable than any training on the wheel.) If you are
a student, perhaps you can find a craftsman who is willing to take you on as an
apprentice or simply let you hang around and watch. This type of experience is
invaluable, since a working studio is very different from a school situation. Some
craft organizations—New York State Craftsmen, for example—and some colleges
are now trying to place apprentices with craftsmen for this reason.

3 *Publication 334, 1972.

Visit some shops and galleries which carry crafts similar to yours; talk with the owners about pricing, turnover, etc. to help you define your market. Ask one of them to carry a few of your pieces on consignment. If you know someone running a gift shop or gallery, this is ideal.

Do some reading. We have listed a number of books and publications we have found useful in the bibliography in the back of this book.

Join some professional organizations—they will provide you with newsletters or magazines with helpful information as well as eligibility to enter the shows which they sponsor. This can be costly but is definitely worth doing to help you get started. At present, we are members of The American Craft Council, The New York State Craftsmen, Lake Country Craftsmen, and the North Syracuse Art Guild, as well as subscribing to *Ceramics Monthly* and *Artisan Crafts* magazines—almost $50 a year in fees.

See if there is an adult education or BOCES (Board of Cooperative Educational Services) course offered near you in small business management. We found this well worth the $15 it cost.

ESTIMATE YOUR NEEDS

After you have done a certain amount of research, try to estimate your approximate production needs and capacities for a week. For example, we decided in 1972 that we needed $7,000 a year to live on. To net this, we estimated that we needed to sell at least $12,000 worth of pots per year to cover materials and overhead. This amounted to $1,000 per month or $250 per week worth of pots. It was only after trying this type of production for several weeks that we determined that we probably could do it. At that point we were earning about 50¢ an hour and working 60 to 80 hours each a week, but this has improved with increased efficiency.

Once you determine that you can produce enough to live on, you have to predict whether or not you can sell the desired quantity of items. This is much harder to determine ahead of time, but you can get a good feel for it, as mentioned earlier, by visiting shows and shops and talking with other craftsmen. It is especially important at the outset not to be rushed into quantity production before you have established your style and your skills.

CONSULT PROFESSIONALS IN RELATED FIELDS

If you have gotten this far and still want to pursue your craft as a living, or even as a second income, go one step further and consult some professionals in the business field. (This subject is covered in more detail in Chapter 2.)

Call the Small Business Administration office nearest you (check the Yellow Pages to locate it), tell them that you are starting a business and don't know

what you are doing. This office will send you a list of pamphlets, tax forms, etc. This is a very valuable source of information and most of it is free.

Call the Internal Revenue Service office nearest you for publications which apply—especially their *Tax Guide for Small Businesses.* *

Talk to a tax accountant about how to set up your books. You have probably just been jotting down the money that comes in on one side of a notebook page and what goes out on another. Once you've filed an income tax return, this can be refined somewhat to make your job easier the following year. There are also simplified bookkeeping methods which many find helpful. We recommend keeping your own books so you understand your finances better, but it is definitely worthwhile to have a professional help you file your first income tax return and set up your books.

Talk to an insurance broker about extra insurance. Most homeowner policies no longer apply when you operate a business in your home. For example, our barn, which is our studio, needs a special policy to cover it now, whereas it was formerly covered by the homeowner policy before it became our studio. You should also check into special kinds of liability insurance. These are discussed in more detail in Chapter 2.

You will also have to look into individual health insurance policies. The biggest advantage of working for someone else was in having that taken care of for us at a much less costly rate. Check into the possibilities of joining a group which can get better insurance coverage at a lower rate for you.

Talk over your plans with a lawyer—ask him about filing a d.b.a., (literally "doing business as" or "under" an assumed name), to make your business more official. You can also discuss the legalities of consignment selling, taking wholesale orders, the pros and cons of incorporation, and anything else he may be aware of.

At some point you may want to discuss your plans with a printer (a fellow craftsman). He will be able to estimate the expense involved in printing up special tags, business letterhead, business cards, price sheets and order forms, and even a brochure or catalog at some time in the future. The tags and the business cards are a good investment even from the beginning, because they will give you the appearance of being professional.

THE TRANSITION

While you are researching the craft business, you should also be getting your own spending and overhead (your fixed costs) way down. The lower your overhead, the better your chances of survival. Set aside some money to live on while you are still getting yourself established. If you don't have any reserve, you may be forced to quit just as you are getting underway.

Set aside some investment capital for your studio. As you set up a studio with

*In Clifford M. Baumback, Kenneth Lawyer, and Pearce C. Kelley, "Factors in Small Business Success" (Englewood Cliffs, N.J.: Prentice-Hall, Inc., 1973), pp. 39-56.

enough equipment, space, utilities, etc. to handle your increased production, invest *only* if you are quite certain that the equipment will be of significant value to you. Try to do without a lot of new things; do all your own work, if possible; use whatever scraps of materials you can find around. Make sure that you have your basic suppliers established and that you have enough money set aside to start buying your materials in larger volumes. By investing more money to buy in bulk you may be able to save some money.

If you are expanding or building a new studio, check all zoning ordinances, building and fire codes, etc., especially if you live in a residential area. Once you have established yourself as a full-time craftsman, you may want to build a studio somewhere besides where you live. This has the advantage of giving you back a certain amount of privacy as well as more regular hours. When you work at home, people tend to call or arrive at any time of day or night, which can be quite disruptive. At first, however, expanding your home studio, thus minimizing your overhead costs, outweighs the disadvantages.

The help that comes from friends who support your efforts is inestimable— probably more valuable than all prior research and planning. To us, this was the major reason for staying where we were while developing our craft into an income-producing business. Once you have done some marketing, you may decide that you wish to relocate entirely, for various reasons. All these major changes should be postponed until you have gotten yourself well underway in as familiar surroundings as possible as gradually as possible. While the peacefulness of a rural studio had originally appealed to us, we have found real satisfaction in remaining in a small community and filling cultural and educational needs there—more in the tradition of the 19th-century artisan than the more isolated 20th-century artist-craftsman.

By staying put, you retain the option (and sense of security) of keeping a part-time job or having a spouse work part- or full-time if you discover that you cannot or do not wish to support yourself as a full-time craftsman.

Many will never take the final step of severing all financial ties with a regular job, but more and more part-time craftsmen are trying it, and many are succeeding. Whether we have managed to succeed so far because of what we did or in spite of it is debatable—it is very much an individual decision and commitment, and even then, there is a good deal of chance involved.

2 Maintaining Law and Order

We claim no expertise in the area of taxes, bookkeeping, insurance, or the law. We will try to explain in simple terms things that you should be aware of. Beyond that our advice is to consult professionals in these fields *whenever* you need to and to be aware that they can help you.

Before we talk about keeping records, we should mention that there are three forms of business, in legal terms—the single proprietorship, the partnership, and the corporation. Whether you realize it or not, you probably fall into the first category, unless you have actively filed papers to become a partnership or a corporation.

Ninety percent of all businesses starting out are single proprietorships; when you are in a fairly low income bracket, the single proprietorship appears to be the most advantageous form of business.

The important advantage of incorporation is that the corporation will be held liable for debts or lawsuits against it, rather than you, the individual. Another advantage is your eligibility for Workman's Compensation, a definite advantage since disability income protection insurance is difficult and costly to obtain privately. New Hampshire is the only state where sole proprietors are eligible for workman's compensation benefits. In all others incorporation is a pre-requisite.

7 The disadvantage to incorporation appears to be the increase in paperwork as

well as in the rate at which you are taxed (minimum 22 percent). You are also taxed double in that your salary is taxed as well as the profits from the corporation. Suffice it to say that this is definitely an area for the experts, and it is worth discussing with them.

At any rate, you can protect yourself somewhat from unexpected lawsuits, if you are not incorporated, by taking out proper insurance for your studio, if the public has entry to it, and for your products. You could conceivably be sued by a customer who had an injury occur in your studio or who was harmed by your product—if he had a casserole break and burn him, had a child injured by a defective toy, developed an allergy to wool, etc. You should, of course, take all measures possible to prevent this from happening—proper labeling is a method discussed toward the end of this chapter. You should still be covered by insurance in the event that something unforeseen should happen.

WHY SHOULD I KEEP RECORDS?

First of all, the IRS (and many states) say that you have to keep records, whether you enjoy it or not, so that you can file and pay state and federal governments what you owe them each year. (Even if you end up not owing them anything, you need proof of this.)

If you are doing your craft part-time, you will need records to convince the IRS that this is a business being run for profit and not just as a hobby. A good set of books demonstrates your serious intention to run a business. If they decide that you are not in business for profit, but are doing your craft for pleasure, you are not allowed to deduct expenses in excess of income. In other words, you cannot declare losses unless this is a business.

Second, and equally as important, you want to know whether you are actually making money. Keeping track of your costs and subtracting them from your income is really the only way to know.

You also need to keep records in most states for state sales (and income) tax purposes. And if you should need financial assistance you will need a set of books. You may need a loan from a bank for your business (these are very difficult to obtain normally); you may wish to buy a new house; you may even need food stamps or welfare assistance. People giving you this type of assistance usually want to see your records first.

KEEP A FILING SYSTEM

Besides keeping a book where we record income and expenses, and some slots in the roll-top desk where we keep all our receipts, we also keep two file boxes. In the small one, usually by the phone, we keep cards with the name, address, and phone number on it of other craftsmen, shop-owners that we sell to, suppliers we buy from, heads of some organizations we belong to, regular cus-

tomers, and people taking lessons from us. This is handy to have because we can use a card for contacting someone or we can jot a note on it if they call us.

In our big file drawer, we keep manila folders for all the people from whom we buy supplies with copies of their orders and bills, all the shops we sell to with copies of their invoices, newsletters from organizations we belong to, craft show invitations and information, and tax records—both income tax and sales tax—and anything else we might happen to collect. Basically, we're not very tidy, and this is the only way we're able to find anything at all when we need it.

We also keep a notebook by the phone in which we list people's orders when they call, and we keep a list of people who owe us money. A large year-at-a-glance calendar is also helpful and in constant use beside the phone.

HOW DO I KEEP BOOKS?

You do not have to use any particular system of bookkeeping. The government stipulates that records must be permanent, accurate, and complete and must clearly show income and deductions.* In keeping business records, a separate checkbook is necessary. Pay all your business expenses by check; then you automatically have a record of them. It is wise to use sales pads to record individual sales in duplicate and invoices to record sales to shops in duplicate. In this way you have automatic records of your income and expenses, which serve as proof if you should be audited.

You also need a book (journal), in which you record your income on one page and your expenses on another. (This is called the "cash" method as opposed to the "accrual" method of accounting.) You can just get a lined notebook at first, or you can get a simplified bookkeeping notebook, which helps you record items a little more systematically. Several craftsmen and small shopowners we know use and like the Dome simplified bookkeeping notebooks.*

HELP?

Yes, you should get professional help, unless you were a bookkeeping expert or tax accountant in your previous life. Most craftsmen are notorious for their lack of aptitude and interest in this area. If you take it upon yourself to keep all receipts and records of transactions, your accountant can handle the job of making order out of chaos—often this can be done for under $200 a year.

If you will let him help you set up a bookkeeping system, the time you spend

*See *Tax Guide for Small Business,* Internal Revenue Service, Publication 334, 1972, p. 10.

**Dome Simplified Monthly Bookkeeping Record,* Nicholas Picchione, C.P.A., Providence, R.I., Dome, 1973.

in the beginning will make your job much easier and more palatable; it will save your accountant time at the end of the year when he is trying to figure out how much you owe the government, and it will save you money. It also tends to force you to be aware of how much money is coming in and how much is going out—thus you will be more apt to take steps to correct a bad situation before it becomes outrageous.

WHAT DO I HAVE TO KEEP TRACK OF?*

For the benefit of the government, you must record whatever money you earn (*income*) as well as your expenses incurred in earning that money. Every dollar you take in is considered taxable by the government, even though you may have several sources of income (your craft, teaching, tarring roofs, etc.). All expenses created in trying to obtain an income as a sole proprietor (i.e., as a craftsman working for yourself) are deductible. Schedule C is used to report these. However, these deductions are not allowed on your personal tax return, Form 1040, where all income must be recorded, regardless of the source.

You must also keep track of *expenses.* You'll like this section. There are many things you can deduct from your taxable income—and they're all legal. Although expenses are more detailed than income, they are still very logical.

MATERIALS. The first expenditures you need to keep track of are those for your *materials.* This includes raw materials used to make your items and any shipping costs on them, fuel used in the process, and any other materials necessary to the finished piece (for example, we buy rope, leather corks, bamboo handles, clock movements, etc.).

SUPPLIES. These include office supplies, such as stationery, stamps, bags, boxes, tags, postage for shipping, etc; and studio supplies, such as sponges, towels, small tools, etc. Equipment with a life span of over one year is not included here (see *depreciation*).

TRAVEL EXPENSES. These involve expenses incurred as a result of travels connected with your business. When you go to shows or travel to purchase supplies, keep track of meals and lodging and get receipts. Credit cards are ideal, for you automatically get a receipt. Tips are also "on-road" expenses—whether at a restaurant or to someone helping you unload your work.

BOOTH RENTAL. Expenses incurred for booth rental at a show are fully deductible. Pay these by your business check for a record.

TRANSPORTATION. This covers expenses connected with owning and operating your car, van, or truck. You can keep track of these in one of two ways. Either keep all your receipts for gas, repairs, car insurance, licensing, tolls, depreciation, and then figure out your costs; or, instead of itemizing, you can

* See *Tax Guide for Small Businesses,* pp. 63-113, for all information contained under "expenses."

take a flat rate (12¢ a mile for the first 15,000 miles, 9¢ a mile after that). If you are using anything other than a compact car, you should probably itemize, as expenses may be greater than 12¢ a mile.

When you are using your car for family transportation as well, you need to figure out how much you are using it for business, and take only that percentage. The way we do this is to separate our mileage into local and long distance. For each long-distance trip, we record the mileage and then note whether it was a business trip or not. Then we assume that the rest of the miles were local and we take a percent of these (50 percent in our case). Keep odometer readings as carefully as possible in a notebook in the car.

TELEPHONE. These expenses can be figured much in the same way as you figure what percent you are using your car for business. Divide your phone bills into local and long-distance expenses; itemize those for long distance and take a percentage of the local service charge. This can be done monthly when your phone bill arrives. (Note: a "business" phone rate is more costly than a "home" phone.)

OVERHEAD EXPENSES. These include mainly expenses connected with owning and maintaining your house, such as your rent, heat, electricity, water, insurance, taxes, maintenance and repairs, etc. You need to know these for your own personal tax form 1040, anyway. As in the case of car and phone, you must estimate how much of your house is being used for the business—studio space, display and storage space, office space, etc. Your accountant, again, can help you figure this out. It can be done either on a room basis (two out of eight rooms would mean that 25 percent of your house was deductible as a business expense) or on a square foot basis, for which you take the total area of the house and subtract the area of the rooms being used. Use whichever method gives you a more accurate indication.

If you have a separate building as well, such as a barn or studio, you should figure your total expenses on this—heat, light, repairs, liability insurance, depreciation, etc.—and add these to the percentage of your house overhead being deducted as a business expense. If you keep your receipts, overhead expenses can be recorded at the end of the year and need not usually be itemized each month.

PROFESSIONAL EXPENSES. These include money spent for books or magazines on your craft or business; dues in organizations; seminars, workshops, or courses you take in your field.

PROFESSIONAL SERVICES. These include the costs of hiring a lawyer, accountant, etc. This is why we're trying to encourage you to use their services—it's a deductible expense and also lowers your tax base.

CONTRIBUTIONS. Any of your work you give to charitable organizations is deductible only in the amount the materials cost, not the full retail value. (This legislation is controversial and efforts are being made to change it.)

BUSINESS INSURANCE. Expenses for insurance such as product liability, or other types of insurance such as theft, damage, etc., which you purchase for

your products, are deductible. (Studio insurance was included above in overhead expenses.)

CHILD CARE. You may deduct these expenses if they are incurred to enable the mother to work. If both parents are earning under $18,000 per year, up to $400 per month can be deducted as a child-care expense.

DEPRECIATION OF EQUIPMENT OR PROPERTY. This must also be considered. If you purchase equipment which has over a one-year life span, you cannot take off the full amount that you spent for it in one year. You must divide it over its useful life span. There are two principal methods of doing this, straight-line and declining-balance, which you can also discuss with your tax accountant.

"You may deduct each year as depreciation a reasonable allowance for the exhaustion, wear and tear, and obsolescence of depreciable property used in your business. If property is used for both business and personal use, depreciation is deductible only to the extent that the property is used in your business."*

QUESTIONS CRAFTSMEN ASK ABOUT INCOME TAXES

DO I HAVE TO FILE SOCIAL SECURITY (SELF-EMPLOYMENT) TAXES? Yes, if your net earnings are over $400. Self-employment tax is part of the system for providing social security coverage for persons who work for themselves. In the case of a husband-wife team, social security is usually paid into the husband's account.

You must file an income tax return and pay a self-employment tax even though you are not otherwise required to file an income tax return (schedule SE, form 1040). To compute this, you multiply your net profit or loss from schedule C by 7.5 percent up to a maximum of $9,000 (these rates change constantly). Even if schedule C shows a loss, you must still file a schedule SE. Your accountant will file this with your income tax form 1040 C.

WHAT ARE ESTIMATED TAXES? DO I HAVE TO FILE THESE? Yes, sole proprietors or partners must file a declaration of estimated income on form 1040 ES if the total of their estimated income and self-employment taxes for the year exceeds their withholding (if any) by $40 or more. (There are penalties for failure to pay a correct installment when due.) Our accountant files our estimated yearly income tax in full. This eliminates quarterly filing. Quarterly filing is also not necessary if you estimate that you will not owe any taxes, which is often the case with craftsmen in their first or second year.

HOW DO I FIGURE OUT WHAT MY "INVENTORY" IS AT THE BEGINNING OF MY TAX YEAR? To compute schedule C. an inventory is needed which includes the cost of raw materials on hand, supplies to be used in the finished product,

*Ibid., p. 75.

and all finished or partly finished goods (items that are in the works, on your studio shelves, or out on consignment—these are still considered your property until they have sold). There are several methods of figuring inventory. Consult the IRS "Tax Guide to Small Business," which explains this clearly, and always use the same method once you have extablished it.

CAN I SET ASIDE SOME MONEY FOR A PENSION? Yes, talk to an insurance or pension expert about this. Even if you are not incorporated, you can set aside some money each year (10 percent of your income or $2,500, whichever is less), which will not be taxed, as a pension fund.

SALES TAX

In most states you must collect sales tax on items that you sell directly to the public. In order to do this you must apply to your state sales tax office (check the Yellow Pages again) for a *tax number,* which is actually a permit to collect sales tax. You must declare and pay quarterly the amount of money you have collected.

Some counties and even some cities have additional taxes. For example, if we go to a show out of our own county in New York state, we have to keep track of what the local sales tax rate is there and how much we collected (or how much pottery we sold) at that rate.

If you sell some of your wares wholesale or leave them in a shop to be sold on consignment, the person running the shop becomes responsible for paying the sales tax on your work. You must, however, keep a record of his tax number and the value of the work he has sold for you.

When you file your sales tax quarterly, you declare the full amount or gross that you made, and then the taxable amount of work that you sold. The taxable will further be divided into region (e.g., $250 worth in Jones County at 4 percent, $775 in Smith County at 6 percent, $2,345 in Home County at 7 percent). The taxable sales are then added up, and this is what you pay tax on. You may record the money you take in for sales tax in a separate column, beside the one in which you record the total amount of sales (excluding tax). *Example:* If your state sales tax is 5 percent, divide your total receipts (money) by 105 percent to find the taxable amount. If, for example, you come home from a fair with $735.00, divide by 1.05. You get $700. This means that $700 is your money and $35.00 (or $700 x .05) will go to the state sales tax office at your next quarterly filing. When recording this in your books, you may wish to record $700 in your "receipts" column and $35 in your "sales tax" column to keep the two separate. Be consistent, however.

Your tax number is also useful when you are purchasing raw materials to be used in making your items. You will not have to pay sales tax on these if you show the company your tax number. For example, we do not have to pay sales tax on the gas we use to fire our kiln. We do have to pay it on the fuel to heat the building, however.

If you do go to a show in another state, you will probably have to obtain a temporary sales tax number and collect tax while you are selling in that state—which you will then have to file and pay either on the spot or within thirty days.

If you ship items out of the state, however, you need not pay sales tax to either your state or the state to which you are shipping the item.

Tax rules vary by state. The best thing for you to do is to consult your local sales tax office and get its booklet of rules and regulations. People in that office will explain confusing things to you if you ask for help.

INSURANCE

After (or before) you consult a tax accountant and get your books and files set up, consult at least one insurance broker. (We mentioned liability briefly earlier.) Talk to an insurance broker about product liability coverage and personal liability insurance. These are available and essential. Also ask about special insurance for your work when you are traveling to shows—e.g., damage, theft types of protection. Often special temporary insurance is too expensive to be warranted, but sometimes this is not the case.

It is important that you consult a broker, a creative one who will rise to the challenge, and not an agent for a specific insurance company. Our pessimism is not warranted in all states, we understand, and insurance laws do vary considerably from state to state. Expect to spend some time on this, however.

Two principles that can be applied to procuring insurance are these:

Don't risk more than you can afford to lose. If a particular loss would put you out of business—such as a major fire in your studio, or your own permanent disability—the risk should be transferred to the insurance company.

Don't risk a lot for a little—i.e., if the premiums for a particular type of insurance are very high it may not be warranted if the risk is not of major proportions.

The added complication for craftsmen is that some types of insurance are not even available to him (or especially to *her*). It is often very difficult (or very expensive when possible) to insure the contents of your studio. It is also very difficult at present for unincorporated craftsmen to get reasonable disability income protection. (It is almost impossible for women who "work for their husbands" or work at home to get it.) Neither the craft movement nor women's liberation has been adequately responded to by most insurance companies or able to attract enough interest in this issue on the part of tax legislation to date.

Craft organizations such as the American Crafts Council and the New Hampshire League are already procuring some types of group insurance for member craftsmen which individual craftsmen are now finding prohibitive or unavailable. If you do not have adequate insurance, make sure you have some money set aside in a contingency fund. When insurance becomes available at a reasonable premium, you should consider purchasing more, even at the expense of joining a group.

The whole question of insurance can be terribly time-consuming and frustrating. The professional services of a creative insurance broker or of a craft organization providing special group insurance policies for craftsmen are very helpful, if available.

FINANCING

The Bank of America booklet on handcrafts has this to say about financing:

> As the prospective owner of an unconventional business you may have difficulty obtaining conventional business financing to get yourself off the ground. Few bankers are willing to risk depositors' funds on loans to independent craftsmen—particularly those craftsmen just starting out.*

If you do intend to apply for a loan, especially once you have established yourself somewhat, a written business proposal can help sell your idea. This should include a description of your work, an analysis of the market and/or your competition, how much equipment or space you will need, how you propose to sell your work, and personal and business financial statements.

It is our opinion that the sooner craftsmen run their studios as businesses, the sooner the business community, notably banks and insurance companies, will take their needs seriously and begin to provide adequate services—especially adequate insurance protection and adequate financial assistance.

LEGISLATION

We have mentioned tax accountants and insurance brokers as professionals you should get to know. You may also need to consult a lawyer occasionally. You've heard it before, but don't sign *anything* until you've consulted your attorney.

In the beginning a lawyer can file a d.b.a. for you, which is the way you register your business and its name officially with your county. In order to get a business checking account, you must show the bank a copy of this record.

A lawyer can also check over any forms (such as consignment agreements or your order form with its wholesale terms on it) and advise you as to their appropriateness. These should be treated as legal contracts. You may also be able to discuss legalities of zoning with a lawyer.

There are also certain laws that are particularly applicable to craftsmen, and a lawyer's advice as to how to interpret them may be desirable in certain instances. (We appear to be headed for even more government legislation in the area of labeling and product safety.)

*"The Handcraft Business," *Small Business Reporter,* p. 11 (San Francisco: Bank of America, 1972).

TOYS

The Food and Drug Administration has the power, under the Child Protection and Toy Safety Act of 1969, to ban potentially harmful toys. A provision of this act requires retailers to refund the purchase price of a condemned toy. The store-owner in turn can seek reimbursement from the manufacturer. (Note: In legal terms, a craftsman is a manufacturer.)*

TEXTILES

According to the Federal Wool Product Labeling Act, all articles made of wool, except floor coverings, must be labeled as to the percentage of virgin wool and of reprocessed and reused wool content. If any other fiber other than wool is present in excess of 5 percent, its percentage must also be given on the label.

In a similar manner, the Federal Fur Products Labeling Act outlaws deceptive labeling of fur. There is a list put out by the Federal Trade Commission, which administers these acts, known as the Fur Products Name Guide, for use in properly describing furs and fur products.

The Federal Trade Commission's Trade Regulation Rule, "Care Labeling of Textile Wearing Apparel," became effective July 3, 1972. It requires that "any textile product in the form of a finished article of wearing apparel must have a tag permanently affixed or attached thereto by the person or organization that directed or controlled the manufacture of the finished article, which clearly discloses instructions for the care and maintenance of such article... Fully inform the purchaser how to effect such regular care and maintenance as is necessary to the ordinary use and enjoyment of the article, e.g., washing, drying, ironing, bleaching, dry cleaning, and any other procedures regularly used to maintain or care for a particular article; warn the purchaser as to any regular care and maintenance procedure which may usually be considered as applying to such article but which, in fact, would substantially diminish the ordinary use and enjoyment of such article."* (Example: "Machine wash warm. Gentle cycle. Do not use chlorine bleach."

POTTERY

To date, such labeling legislation does not exist in the case of pottery used to contain food, but should be undertaken voluntarily by potters. (There is a law specifying the safe limit of lead, but most potters stay away from lead glazes entirely.) Inform the customer that the glaze is lead-free; that the pot can be used to bake food in the oven (or on a burner if it is actually flame-proof); that it can be put in the refrigerator or freezer for storage; that it can be washed in the dishwasher; and that care should be taken to avoid sudden changes in temperature. With growing consumer awareness, craftsmen making functional items should all develop informative labels for their work.

*Baumback et al., *How to Organize and Operate a Small Business,* pp. 494-95.

Outlook, newsletter of the American Crafts Council, (July 1972), p. 3.

Another piece of legislation that is somewhat applicable to all craftsmen regardless of media is the Robinson-Patman Amendment to the Clayton Act. This deals with price discrimination. In essence, it says that you must give the same terms to all buyers in the same geographical location and at the same point in time. Its intent is to protect buyers from unfair competition of other buyers. Whereas the "merchandise" in the case of crafts can always be claimed to be of slightly different character or quality, thus justifying a difference in price, the terms of discount and payment given to different buyers should be consistent.

Note: You do not have to sell to anyone you prefer not to (provided you are not discriminating on the grounds of sex, race, or color). You also do not have to sell at a mismarked price. A deal is not complete until you have accepted the money the customer has offered you.

Also of interest to craftsmen in various media is copyright legislation—especially that concerning the original design of functional items. H.R. 8186, introduced May 29, 1973, if passed, will be important to craftsmen who wish to protect original designs.

3 Pricing for Survival

This chapter is a little heavier, but we all need to get into this subject at some point to survive. For most craftsmen, setting the right price is their single biggest problem.

As craftsmen, we wear two sets of clothing—one as producers, one as sellers of finished products. We need a pair of pants for both suits—or in business terms, a "margin"—if we are to have control over both these operations.

When producers get into pricing, their margin includes costs, such as materials, overhead, labor, even profit; when retailers get into pricing, their margin includes similar costs, such as wages, overhead, and heavy selling expenses, such as advertising, and also profit. Notice we use the term *profit* to mean extra money left over after all possible expenses incurred have been deducted from the sales, or income. We use the term *margin* to include all expenses and a cushion of profit.

As producers you should collect enough money (margin) to take care of the costs of producing; as sellers of finished goods you should collect enough money (margin) to take care of those similar costs of selling, as well as the costs of buying the finished goods. If you do not collect both margins (to stretch our metaphor), you will eventually be caught walking around without your **18** pants on. . . .

As a producer, your job is to arrive at a wholesale price that takes care of a calculated margin; as a seller, your job is to arrive at a retail price that takes care of a second calculated margin. Both of these are influenced by your costs and by consumer demand, or how much people are willing to pay.

At the end of the chapter is a worksheet with sample figures and space for your own calculations. You may refer to it while reading the following material.

COST OF PRODUCING

First of all, look at your costs as a producer (studio craftsman). These can be broken down into three parts—materials (raw materials used in making your work and others necessary to the finished piece), overhead (the costs of operating your studio), and labor (an hourly wage for yourself).

As a seller, you are (or someone else is) buying your work from yourself. Your (his) costs include the cost of buying the finished goods (your wholesale price) and your (his) costs of operating a shop or going to a show.

Your second consideration in arriving at a price is based upon the market—or consumer demand. When, after analyzing your costs, you come up with a selling price, you then must determine whether or not the market will bear this price. Or you can reverse the process, set a price that the market will bear, and then figure out whether you are covering both the costs of selling and the costs of producing.

Whether you are a producer or a seller, many of the costs included in margin will be fixed and won't change over a period of time—i.e., rent, utilities, insurance—while other costs will vary with the amount of work you make to sell. In any business these are known as fixed costs and variable costs. Fixed costs are there no matter what you do; variable costs depend upon the number of pieces produced and other individual judgments, such as how many phone calls you make, whether you advertise or not, how many supplies you need, etc.

As you can begin to see, you need a minimum amount of money from the sale of each item to take care of a share of the fixed costs, the variable costs, and a cushion of profit. If your sales (income) over a period of time, say a year, will cover all your fixed costs and all your variable costs, you have broken even (this is called the "break-even point"). This includes a certain amount for your labor whether you calculate it as a yearly amount (fixed) or an hourly rate (variable). If income from sales *exceeds* those fixed and variable costs, you have that cushion of profit we've been referring to (or a higher wage if you prefer to think of it that way). You can build this profit into your margin along with your other costs. However, most craftsmen tend not to think in terms of profit in determining a price—but this profit cushion does act as insurance against things like a rained-out show, a bad kiln, or a drop in sales, and should be considered.

Now we will get into figuring margin (costs) as producers. The worksheet at the end of this chapter should be useful in working these up.

WHAT ARE YOUR MATERIAL COSTS?

These include raw materials, fuel, and direct supplies. Sample costs for a potter who fires a 10 cu ft kiln 100 times a year are included in the following table:

Materials	Per Year	Per Kiln
Clays and glaze materials	$1500	$15
Firing costs	1000	10
Supplies (cork, leather, rope, etc.)	500	5
Apprentice	500	5
Total Costs	$3500	$35

WHAT ARE YOUR OVERHEAD COSTS?

These include basically the same expenses that are deductible on your income tax, unless they have already been listed as materials. Sample overhead costs for the same potter follow:

	Year	Kiln
Transportation (local)	$ 250	$ 2.50
Tools and consumables	500	5.00
Office supplies	150	1.50
Advertising	100	1.00
Professional services	50	.50
Utilities	500	5.00
Insurance, taxes, etc.	200	2.00
Depreciation	700	7.00
Miscellaneous	50	.50
Total Overhead	$2500	$25.00

What is the total of material plus overhead (excluding your labor, at this point)? For the sample potter, the total would be $6,000 per year or $60 per kiln (assuming 100 firings a year).

What percentage are the material and overhead costs of gross? If your gross income is $24,000 a year and your materials and overhead are $6,000 a year, it is easy to see that your costs (excluding labor) are one-quarter of your total sales, or 25 percent.

Craftsmen should figure a certain amount of loss into their overhead costs for items that cannot be sold because they come out damaged or of poorer quality. The clever craftsman will figure out a way to minimize these losses.

As potters, we do quite a bit of experimenting with glazes. At first we used to fire sample blobs which were useless after being fired. We then discovered that if we made little weed pockets, which were quick and easy, and used those for glaze tests, we could sell most of them afterwards. Another thing we do, is to sell

at half-price our "seconds"—items with minor defects—out of our studio (clearly marked and put on a shelf for seconds). We get almost the same amount we would get if a shop bought the item wholesale as a first (we never sell seconds to shops). And people love it—many wait specifically for something defective to come out. They're happy to pay less, and the item isn't a total loss for us.

Time that is spent designing should be calculated as carefully as research time. This varies from craft to craft, but must be taken into account in pricing your work. Creative attempts can also be used to eliminate "waste" here.

WHAT ARE YOUR LABOR COSTS (OR HOURLY WAGE)?

To arrive at this, it is necessary to do the following calculations:

Figure out how many hours you work a week at your craft (plus bookkeeping, selling, shopping for supplies, doing repairs, etc.). The two of us spend 60 hours each or 120 hours total.

Estimate how much you can produce in a week (assuming you are not going to a show) at maximum production. The two of us in a really good week (120 hours) can produce $1000 *retail* value worth of ware.

Figure out what your cost of selling is, or, put another way, what the wholesale value of that work is. This depends on how much you sell yourself—at home and through shows—and how much you sell to shops, as well as what your wholesale discount is to shops. The maximum again would be to sell at a 50 percent discount to shops entirely. Taking the maximum discount, the wholesale value of a week's worth of work would be $500.

Next, subtract your material and overhead costs. We arrived at an average figure which was 25 percent or one-quarter of the retail value. Twenty-five percent of $1,000 would be $250. This leaves us with $250 for 120 hours worth of work, or just over $2 an hour as a wage.

Can you reduce your cost of selling by going to some shows or selling out of your studio—in other words, by taking over the second function of "seller" that we were talking about earlier? If so, you will have more money for yourself, which you can call either a higher hourly wage or profit. But in figuring your "minimum" hourly wage, consider yourself only the producer and not the seller of the goods. You should be able, obviously, to live on this wage that you set as a minimum. If you can't, you will have to raise your prices. In reality, our cost of selling averages about 30 percent, so our hourly wage is closer to $3.75 per hour than $2.00 an hour.

SOME OBSERVATIONS ON CUTTING COSTS

As can be easily seen from the preceding guides to pricing, if you can decrease either your material and overhead costs or the amount of time involved in making or designing an item, you will be able to make more money for yourself. In addition to the rapidly rising cost of materials, the craftsman has to cope with the problem of buying most materials at retail prices or at a slight discount for bulk and then turning around and selling his finished work at a wholesale rate. It

is possible that in the interest of keeping prices "reasonable," the shops are going to have to share some of the burden with the craftsmen for cutting down on costs. Craftsmen are usually working at a minimum salary already, and most feel that the shop-owner is making a lot more money from their talent than they themselves are.

The quality of the finished piece should never be compromised in the interest of making more money. "The moment ideals of art are relinquished for the sake of quantity production or seemingly more rapid sales, danger lies ahead," according to Royal Bailery Farnum, one of the founders of the League of New Hampshire Craftsmen. "What is art? It is the doing something well. It is not the thing that is done . . . it is the way that it is done," according to another N.H. craftsman.* In other words, the chief advantage of working for yourself is in being able to do things your own way, the right way.

There are certain costs in operating a studio that we personally would not cut. One is studio space. A certain minimum amount of space, apart from your living area, has to be maintained if you are to work with any kind of ease and efficiency.

Another cost that we wouldn't cut is in the area of studio safety, especially because the public does come to our studio, and because many types of insurance are difficult for craftsmen to obtain. One hazard to potters, apart from the kiln, is the small particles of silica entering the lungs which can result in silicosis. Face masks can be worn or other precautionary measures taken. Craftsmen working with stained glass and lead-soldering run a very real risk of lead poisoning from the fumes if they do not ventilate their work area. Anyone who works with fire—iron workers, glass blowers, potters—has to be conscious of the fire hazard involved. Spend a little time and money on your own health and safety.

Another cost we feel should not be cut is in the area of protecting the environment. Remember how critical we've been of industry for putting economic motives above environmental considerations? Scrounge materials, use recycled paper, use cloth rags instead of paper towels; be conscious of your wastes—are they polluting air or water? Where do your raw materials come from—are you wasting them unnecessarily? For example, as potters, we have been able to cut our fuel (propane) consumption more than 20 percent by the use of a simple and inexpensive flue gas analyzer which measures efficiency of combustion. Not only does this decrease air pollution and conserve gas (also money), it has eliminated "bad kilns" with measurably consistent reduction firings.

If materials are in short supply, invest now and buy in quantity. This is insurance against running out at a bad time (right before Christmas) or running out entirely. Get to know your suppliers, if you can— what do they project for the future? The fuel shortage is affecting us all, as are shortages of some raw materials.

Another consideration in cutting costs is whether or not you should use equipment rather than doing a certain thing by hand. This is a matter of judg-

*Betty Steele, *New Hampshire League History,* Part I, "The Pioneer Period," unpublished.

ment—at what point does your work become "manufactured" and not hand-made? Too much reliance on the work of apprentices can hold the same dangers. The quality of the finished piece should never be compromised because you are trying to fill orders too rapidly—you could destroy yourself in the process.

EXCEPTIONS TO PRICING RULE

We have assumed that you are a production craftsman in setting up our two methods of figuring out a selling price—"forward" by analyzing your costs and setting a price to cover them, and "backward" by setting the price you feel the market will bear and then figuring out whether or not your price covers your costs.

If, however, you are a student and don't have the same costs—i.e., your materials and studio are provided for you—price on a comparative basis. Look around you at fairs or in shops, find some work that is comparable to yours in quality and complexity (if you can), and price accordingly. Otherwise, you may be undercutting full-time craftsmen, and you may be one yourself some day. So forget about a momentary rip-off, even if you do have bills to pay. You may end up not only harming full-time craftsmen but yourself as well by leading people to question your competence, if your prices are too low.

The first-year craftsman, who is pricing by comparing his work to that already on the market, may be making closer to 50¢ an hour than $2 or $3 an hour, but this will improve. He is less efficient with his time and will initially have to discard a larger proportion of his work to maintain quality standards.

If, instead of doing production work, you are doing one-of-a-kind items or custom work, your prices will necessarily be higher. People expect to pay more for originality or for extra time in designing an individual piece. On custom work, it is normal to require a 50 percent deposit with the order and 50 percent upon completion. If it is an expensive order, it is probably wise to have some kind of agreement in writing as well.

Although prices can and should be higher for custom work, uniqueness, or exceptional quality, be careful not to go overboard. The craftsman who has just had a one-man show may be tempted to double his prices. This is pretty unrealistic. You are "worth" what people are willing to pay for your work—no more, no less.

With these warnings and exceptions in mind, let's get into our second method of pricing—the "backward" method, or pricing what the market will bear.

PRICING WHAT THE MARKET WILL BEAR

You can set what you think is a going rate for a pair of silver earrings—a price that you think they will sell at. This is what most craftsmen do anyway. But then work backward and figure out whether you are covering your material, overhead, and labor costs at that rate.

Take three or four standard production items at different prices. For example, we chose

23

Hanging planters (medium) @ $ 6.00
Mugs @ 3.00
Wine sets @ 25.00
Teapots @ 15.00

Figure out a convenient batch size. Even though we never fire one kiln-full of only one item, we worked on the basis of a small kiln-full and took our material and overhead costs as $60 per kiln. We also use a rule of thumb for figuring the *total* time involved in a finished pot, which is wheel time times ten.

Item	Selling Price	X	Batch Quantity	=	Batch Value	Materials & Overhead	Hours
Planter	$ 6		40		$240	$80	20
Mug	3		80		240	60	40
Wine set	25		16		400	60	80
Teapot	15		40		600	60	200

To figure your hourly wage, take the total batch value and subtract the cost of selling, since this is a retail value. We have been working with 50 percent in determining your hourly wage before, so let's stick with it, even though it is probably a little high. Subtract your cost of materials plus your overhead. Then divide by the total hours to figure your hourly wage.

Item	Batch Value	−	Cost of Selling (50%)	−	Materials & Overhead	=	Net Income	÷	Hours	=	Wage (per hr)
Planter	$240		$120		$80		$ 40		20		$2.00
Mug	240		120		60		60		40		1.50
Wine set	400		200		60		140		80		1.75
Teapot	600		300		60		240		200		1.20

Conclusions and Adjustments

These are a first-year potter's hypothetical reasonings. Although three out of four of the pottery items were priced too low to cover a basic $2 wage, we did a very large volume in planters and a small volume in the underpriced items, so the total hourly wage was not far below $2.* How could we, or should we, correct the situation?

On mugs, which we really didn't enjoy making a lot of, we decided to raise the price to $3.50 each. Based on the preceding formula, we arrived at an hourly rate of exactly $2. After using this price for a while it appeared that the extra 50¢ did not influence the customer or change the volume of sales. So we kept that price at $3.50.

On teapots, we first raised the price from $15 to $20, which figured out to a $1.70 hourly wage. However, in this case, sales did drop considerably. Because

*("$2 minimum" in reality became $3.50 per hour when cost of selling was reduced to 30% by selling directly from the studio and at craft fairs.)

we enjoyed making them, we decided to return to the $15 price and balance it out with other items.

We raised the price of wine sets to $27.50 to reach our $2 minimum at no appreciable change in the rate of sales. We then decided to push it a little further to $30. It sounded better. If the sales continued, we would keep it there. This would help balance the teapots we were making too little on.

On more unique items, such as carved candle holders, we experimented with prices at shows and discovered that we sold the same number whether they were priced at $10 or $18. Our minimum wage could be earned at $12, but because these items were unique and we could only produce a limited quantity, we raised the price to $15.

Shortcut Method to Figure Hourly Wage

If you can figure the time and cost involved in a single item without going into the batch concept, its much easier. Let's take three different stained-glass items:

	Selling Price	−	Materials & Overhead	−	Cost of Selling	=	Net Income	÷	Hours	=	Wage
Tiffany flower	$8.00		$2.00		$4.00		$2.00		1/2		$4/hr
Owl	2.00		.50		1.00		.50		1/4		$2/hr
Sailboat	4.00		1.00		2.00		1.00		1/4		$4/hr

COST OF SELLING

Up to this point we have been talking about your costs as a producer. We have set a retail price and given you half of it to cover your expenses. Or, put the other way around, we said that your job as a producer was to set a wholesale price, and then double it to give the seller a margin to cover his costs. Now lets talk about those costs the seller has to take care of in his half of the bargain (the seller may be you or someone else).

First of all, let us assume that the seller is you, and that you are going to shows (which are like temporary shops, really) to sell your work. Craftsmen are likely to feel that a show's expenses are minimal if they only count in booth fee. They may even lower their prices because they think that they don't need that much margin to cover their costs. This is wrong for two reasons. You probably will have more expenses than you think—have you thought about your hourly wage again? Also, as a matter of policy, you should set a retail price and stick to it—if you should make a little more than enough to cover your costs at one show, it will balance out with the bad show where you don't sell a thing.

In this next section, we are going to help you figure out a break-even point for shows. Even though nobody goes to shows just to make money (which we talk about in detail in the next chapter, "Selling at Shows"), you should know whether you covered your costs or not. Would you have been better off finan-

cially to have stayed home and worked, assuming that you could sell all that you made at a later date? Most craftsmen also develop a rule of thumb for the average show, and figure they need to make so much, say $200 per day, to make a show worthwhile financially.

We will figure costs for a low-priced show (say a local show put on by a community organization with very low booth rent and no transportation or overnight costs involved) and a higher-priced show (say 500 miles away, and involving a week away from your production at home and a high cost for booth rental). When we figure time, or an hourly wage, we do not figure the total hours we spend at a show, although you can do that. It seems more realistic to figure the number of hours lost to production, including the time before and after for packing and unpacking. As you will see, the break-even point at these shows depends on the hourly wage you assign yourself. The following sample is figured on the basis of a $2 per hour wage. This is unrealistically low. $3 or $4 per hour is much more reasonable and probably closer to what many (ourselves included) are making as producing craftsmen.

Your first cost in going to a show is in buying your items from yourself. This sounds weird, but you as a producer have set a wholesale price which covered your costs (overhead, materials, labor); thus you, as a seller, have to pay yourself as a producer that wholesale price. Then you the producer are all set, and you the seller can figure out the costs involved in selling.

Let's say you sold $200 worth of your work at the local show in two days, and $1,000 worth of your work at the long-distance show. Did you actually make the same hourly wage you would have made staying home? Did you make a higher or a lower wage as a seller?

Show Costs	Low Price	High Price
Cost of goods @ 50% of retail	$100	$500
Booth fee	5	100
Transportation @ $.12/ mile	—	120
Meals & overnight	10	175
Labor	86	240
	(2½ days)	(one week)
Totals	$201	$1135

As you can see, you did as well in your role of seller at the local show as you would have at home working as a producer. However, your costs were greater than your income at the long-distance show; so even though $1,000 looks like a lot of money, your hourly wage would have been better staying at home and producing (again, assuming that you could sell later all you could produce).

Let us go on to assume that the seller of your work is no longer you but the owner of a shop. The shop-owner now buys your work at your wholesale price, and then he has to cover his costs as a seller in the retail price he sets. Once he buys your work, he can change the retail price which you have set previously. If he alters it too drastically, you have the option of no longer doing business with him, but all shops have a different cost margin to work on.

We have assumed all along a 50-50 split; you as producer get half, and the shop-owner gets the other half of the money. In other words, if you set a retail price of $10 on an item, you would give the shop a 50 percent discount, and charge it $5 for the same item. In reality, many craftsmen do not give the 50 percent discount, which is a holdover from the gift industry. We give only a 35 percent discount to shops and then offer them a guaranteed sales policy (which is explained more fully later on) to help minimize their risk. We also do not have a set minimum-order policy, which means that a shop does not have to tie up a lot of money at once; and we do not charge a packing fee, which is often 4 to 5 percent of invoice. These three factors help compensate for the lower rate of discount.

There is also a concept called *rate of turnover* at work here. If, by keeping prices a little lower, a shop can sell sufficiently more of an item in a given period, their overall profit may be the same or higher. For example, shop A doubles the wholesale price ($5) of a pair of earrings and charges $10. Shop B marks up less and charges $8.50. Shop A sells eight pairs of earrings in March and makes $80 ($40 to cover its costs and $40 to pay for the earrings); shop B, at the lower price, sells twelve pairs of earrings; it takes in $102. The earrings cost him $60 ($5 apiece as with shop A). Shop B is now left with $42, or $2 more than shop A, even though it charged less for the earrings. If their expenses are both the same, shop B has made more profit.

If, however, you cannot supply shop B fast enough, he should be encouraged to raise his prices to see if it will slow down the demand. If shop A and shop B are near each other, their prices should also be more similar.

Of course, price is not the only factor influencing demand—a shop might sell *more* at the higher price for other reasons.

Basically, it is in your interest to keep your prices as reasonable as possible and still cover all your costs. In the past, crafts in craft shops have usually been out of the price range of many people. If, being efficient and cutting your costs, you can price your work so that as many people as possible can buy your work, your chances of survival are much greater. It is usually easier to sell two items for ten dollars than one for twenty. We appreciated Ken Harris' concluding paragraph in his book *How to Make a Living as a Painter*.

As to the lasting worth of your work, you will never know the answer to that in any case. But its merit will not be less, I believe, because you shared the ability you had with as many people as possible.*

OTHER FACTORS THAT INFLUENCE SALES

Still working with the idea of pricing, let's consider psychological prices as opposed to real prices. In general, the .00 ending on an item implies quality merchandise—this is why most crafts you see will be priced at $8.00, for instance, instead of $7.98. There are instances where we have found that .25, .50,

*New York: Watson Guptill, 1970, last paragraph.

and .75 endings work better; if people don't want to pay $9.00 for something and $8.00 is too low a price to cover your costs, you may have to try $8.50 or $8.75.

Some ranges of prices work better than others, as well. For example, whatever we price at $13 will sell at $15 just as easily—$19 will bring $20, but $18 may not bring $20. Be conscious of psychological prices and price ranges and experiment. We know a glass blower who can sell a pair of goblets for $18 but can't get $8 for a single. Pay careful attention to the selling prices you set.

A word about ripping-off. Consumer buying habits are very strange. Occasionally you will set a price that covers your costs, discover that the item doesn't sell, double the price, and have it sell immediately. Just as often, though, you may have to lower a price to sell an item. Being able to collect the higher price (profit) isn't a rip-off; it merely enables you to balance out the items that sell under cost or take care of unforeseen adversity. When done in moderation, this is a survival technique.

There are other very interesting psychological and sociological factors influencing the consumer. We have been talking about price as an economic factor as well as a psychological one. (Another economic factor that bears mention is the availability of credit.) Psychological reasons for buying a product have to do with people's concept of who they are.

> The customer seeks to identify his own personality and make himself stand out from the masses. Purchasing quality products offers him a way to be an individual in the crowd and create an image of himself which will give him satisfaction and pride.*

Social reasons for buying include status and prestige. Pricing does affect this level in that one may feel that if an item is expensive, it is naturally more desirable.

In many cases, crafts have become a status symbol. In recent years the home has replaced the automobile as the most important status symbol—crafts which enhance the home are therefore very "in." Be aware that you are selling a symbol as well as a product.

Also be aware that people need to rationalize—it is the rare person who will come up to you and say, "I need a status symbol," A more acceptable reason for buying your work would be *function*—"I need a belt" or "I need a gift." If you can help provide your customer with a reason for buying something, you may be able to influence him enough to purchase the item.

Along with the need to rationalize, people have a need for security—some more than others. Occasionally this influences them to buy a "name" craftsman's work. It may also influence them to prefer buying from a shop whose owner's taste they trust more than their own.

People also buy in accordance with how others see them, and those in the same peer group have similar buying patterns. One of the main peer groups buying crafts now tends to be younger than average, have slightly higher income and

*Robert Myers, "Quality and Taste as Sales Appeals," in a S.B.A. Report, quoted by Charles Counts in *Encouraging American Craftsmen,* Washington, D.C.: U.S. Government Printing Office, 1972.

educational levels than average, and have a positive orientation to counter-culture values. Some may look like suburbanites, but they think of themselves as young and "with it." After a few craft fairs, you develop a knack for spotting the types who are more likely to be turned on to crafts.

In some cases, customers find themselves in a similar peer group with the craftsmen—in fact, craftsmen *are* good customers (although they may barter with you instead of paying money, which is fine). This identification with crafts-men gives the customers and additional incentive to buy. They will also tend to feel that their money is supporting something they believe in and not a large impersonal department store. Using money to influence social patterns, such as supporting the efforts of poor people (as in the case of urban and rural co-ops) or starving artists (as in the case of craftsmen at a fair) contains all three of the motivations we have been talking about—economic, psychological and social—to a degree.

WORKSHEET FOR FINANCES

		Sample Figures	Your Figures
I.	*To figure your material costs and overhead* (see pp. 20-21)		
	1. Your direct material costs per year (raw materials, fuel, etc.).	$ 3,500	
	2. Your overhead costs (expenses of operating studio).	$ 2,500	
	3. Total of nos. 1 and 2.	$ 6,000	
	4. Your total (gross) income per year.	$24,000	
	5. Your average material and overhead cost (divide no. 3 by no. 4).	25%	
II.	*To figure your hourly wage* (see p. 21)		
	1. Number of hours you work in a good week.	120	
	2. Amount of ware (full retail value) produced in one week.	$ 1,000	
	3. Your material and overhead costs (multiply no. 2 by % figure from Section I, no. 5).	$250	
	4. Your cost of selling (take maximum, usually 50%).	$500	
	5. Add nos. 3 and 4 and subtract from no. 2 for the amount of money you earn.	$250	
	6. Divide the total in no. 5 by your total hours to get your hourly wage.	$2.08/hr	

III. *To figure your cost of selling*

AVERAGE COST OF SELLING (see pp. 25-27)

1. Amount of work you sell wholesale and discount at which you sell it. 1/2 @ 40%

2. Amount of work you sell retail. (We use 20% as our average cost of selling retail.) 1/2 @ 20%

3. Average cost of selling. (In this case it is halfway between 20% and 40%—or 30%. If you sold one-third wholesale and two-thirds retail, your average cost of selling would be about 27%.) 30%

COST OF A PARTICULAR SHOW (see p. 26)

1. Transportation (@ 12¢/mi). 1000 mi x .12 = $120

2. Food and overnight accomodations. $170

3. Time (amount lost to production). 1 wk, 120 hrs

4. Multiply no. 3 by hourly wage from Section II. (Ex: one week = 120 hrs @ $2/hr = $240.) $240

5. Wholesale value of work you sell at show. (for $1,000) $500

6. Booth fee (% or flat rate). $100

7. Total costs. $1,130

IV. *To figure whether or not you are making your hourly wage or losing money on particular items* (see pp. 23-24)

1. Price of the item. glass owl @ $2.00

2. Material and overhead (25%) plus selling costs (50%). $1.50

3. Subtract no. 2 from no. 1 for the money you receive for yourself. $.50

4. Amount of time you spend to make the item. 10 min (1/6 hr)

5. Your hourly wage (divide no. 4 by no. 3). $3.00

30

4 Selling at Shows

INTRODUCTION: METHODS OF SELLING YOUR WORK

In the next two chapters we deal with the *direct* ways of selling your work— either *direct retail* or *direct wholesale.* Direct retail includes selling through craft fairs, which is the method this chapter deals with primarily, and selling out of your own studio. Direct wholesale includes consigning or selling outright to a shop which then sells your work for you—the topic of Chapter 5. These category names have been excerpted from a column by Michael Higgins, who writes for *Craft/Midwest.* He and his wife Frances have been earning their living as glass craftsmen for twenty-five years, have tried all the methods outlined here, and have gone back to the direct channels of selling.

Mail-order selling and selling through department stores can be done directly by you, as in direct wholesale, or indirectly through an agency, depending on preferences and circumstances. We feel that if done directly, mail-order selling offers very interesting potential to craftsmen. (For more on this subject, see the end of Chapter 5.) We personally are contemplating the possibility of combining

31 *Michael Higgins, "Selling as a Professional: Analytical List of Channels of Selling," Craft/Midwest, Fall 1972.

efforts with a friend who sells antique clocks by a mail-order brochure, including a picture of our hand-thrown clocks and taking orders on them.

As for department stores, we have chosen to stay away from them in the interest of thinking small (there is more about this also toward the end of Chapter 5). But there is a definite market here for craftsmen who care to deal this way. The Higginses, who tried it with the additional help of a sales agency and later withdrew, say that they produce about one-sixth as much work to make the same amount of money when selling directly from their studio and at art fairs. Their advice (and ours) to those considering dealing with department stores, is "Don't."*

The less direct methods of selling, although not the main subject of this chapter, will be outlined here in case you are thinking of using them at some point in time. Less direct ways require larger volume and more concentration on a few "line" items done repetitively. They also allow for less personal involvement with the selling of work. For these reasons, we personally prefer not to sell this way. However, it is possible to sell wholesale through a distributor or sales agency, sell wholesale to a manufacturer, or sell on royalty or salary or both as a designer or engineer.

INDIRECT SELLING

Wholesale through a Distributor*

This indirect method involves placing samples of your "line" in the hands of a distributing agency, whom you usually pay 20 percent of the wholesale value (10 percent of the retail) of firm orders placed with them. Besides the problems of high volume, "line" production, and an additional middle-man, craftsmen have the additional problem of often having to pay the distributor's percentage well before the retailer's payment comes in. The craftsman may, in the end, be lucky to net one-third the retail value for his work and all studio costs, according to Higgins.

There is the additional problem of keeping track of your investment and your work with too many people and too much time involved. We know of one instance in which a leather craftsman prepaid an agent he had not investigated thoroughly; a subsequently painful and costly experience with this dishonest agent revealed false invoices, bogus stores, and other varieties of fraud. Suffice it to say that this method requires relinquishing a good deal of control and should be entered into cautiously, if at all.

Wholesale to a Manufacturer

"This (indirect) method covers cases in which the finished work of the craftsman may be incorporated as a component or a material, into a product manu-

Ibid., "Do You Want to Sell to Department Stores?"

Ibid., "Channels of Selling." Materials from this and the following two subsections are summarized and quoted from this article.

factured and sold by someone else." For instance, a weaver or fabric-serigrapher might sell dress-lengths to a fashion house, drapery yardage to a workshop or, as Michael and Frances did, clockforms to a clockmaker or fabricated glass "jewels" to a maker of cuff-lengths.

Usually cost must be kept low for this method, because there may be as many as four different profits involved—the craftsman's, the manufacturer's, the wholesale distributor's, and that of the final retailer.

On Royalty or Salary

A manufacturer may see a craftsman's work, wish to duplicate it in quantity, and offer the craftsman a salary or royalty (agreed percentage against sales receipts) in return for the right to reproduce certain work. He may also offer the craftsman studio space on his premises. The danger in this is that a craftsman can eventually degenerate into a "paper designer" who no longer even executes his own work.

For the individual craftsman (or crafts-couple) who does not wish to hire help or sell through distributors, selling directly out of the studio, at fairs, and through a few good shops appears to be the most viable course.

Direct Selling: Retail from Your Studio or through Fairs; Wholesale through Shops

Whether you sell a greater portion of your work at shows or through shops may depend on many things. The type of craftsman you are and your location are two important factors. If you do not intend to produce a few items repetitively, but prefer doing what you feel like, you will probably be more inclined to sell through shows ("shows" has been used interchangeably with "fairs") than to accept wholesale orders from shops. You could, however, sell through consignment shops, because these accept whatever work you give them. Or you could sell out of your own studio. If you are in a rural location, your selling patterns will be affected to the extent that you will sell less out of your own studio and will have to either wholesale (or consign) or attend a few craft fairs.

Most crafsmen cannot afford to sell totally to shops because they cannot afford to give up 50 percent to the cost of selling. They therefore depend on doing some retail selling, usually at shows, so that their cost of selling will average out at 40 percent or under. The urban or suburban craftsman may be able to do enough retail selling directly out of his studio that he can go to fewer shows. In other words, to make the same amount of money, you must produce a greater amount of work if you sell wholesale than if you sell retail. Besides your type of work and your location, there are other factors affecting the way you choose to sell. One is your stage of development. If you are just starting out, you will do some selling at craft fairs as well as some consigning. This is necessary and desirable at this stage. If you are more established, have developed a distinctive line that you can reproduce efficiently, can sell as much or more than you

can make, have less need of constant feedback, or less patience with shows, you may tend to rely more on wholesaling to good shops.

Your personality is a definite factor in how much retail selling you do yourself. If you have a strong ego, can withstand a wide range of comments—critical, complimentary, and inane—enjoy dealing with the public and are a good salesperson, you should (and probably will) favor selling at serious craft fairs. If you're not outgoing, you should probably leave this area to someone else.

The price range your work is in *may* be a factor. In general, shows tend to allow you to sell your low-priced work easily and quickly, while shops will do better with your higher-priced items. The reason for this is that shows are more conducive to "impulse" buying, whereas work in shops can be thought about for a while, reexamined over a period of time before a decision is made.

Your family's needs also have to be considered. The show circuit can be strenuous on both children and older people (and even on young people). An occasional show is fun— every weekend, however, may be an imposition on other members of your family. If you do not bring them along, it then becomes a burden on your finances, unless you have a built-in babysitter. (This is the second nicest thing to having a rich uncle.)

How you sell is directly related to rhythm and pace—your own, and that of the outside world. The market also has a rhythmic or seasonal aspect. Sometimes you can take advantage of summer tourism in one shop, fall festivals in another, and Christmas in yet a third. The same goes for selecting shows.

There are certain times of the year that you could be doing nothing but selling retail—Christmas is the obvious one. However, if you plan to do this, you should make sure that you have cut off wholesale orders from shops by late September (this varies) so that they also have enough ware to get them through this busy season. Many shops double their sales in November and triple them in December.

Our yearly rhythm seems to go something like this:

Winter and Early Spring
Restock shops from Christmas sales.
Travel to one big show out of our area (retail selling is slow at home).
Prepare for pre-Easter shows.
Give a series of lessons.

Late Spring and Summer
Put garden in.
Fill some more wholesale orders; prepare for summer shows and studio sales. (We are in an area that is heavily visited by vacationers in the summer; our own studio sales increase dramatically as do the number and quality of outdoor craft shows. Summer is the second busiest time to Christmas, and pre-Easter runs a close third.

Fall
Harvest garden.
Fill wholesale orders for shops for Christmas.
Prepare for November and December retail shows and studio sales.

Your own yearly pace will differ, but it is best to try to work on a general rhythm, to predict, to pace yourself; otherwise you tend to feel constant pres-

sure. We try to sit down with a calendar periodically and map out our working and selling patterns (which are still subject to instant change) to allow us to set a reasonable working pace.

SELLING AT SHOWS: PROS AND CONS

For most of us who are making a living as craftsmen, shows have become a way of life. Picking the "right" shows is important; a few good shows a year can provide the major portion of a craftsman's income, as well as some recreational fringe benefits. Although shows are time-consuming, you are selling your work at retail price, and this adds up quickly. In the section on pricing, we discussed how to figure out a break-even point for shows. If you make over a certain amount of money (our own average rule of thumb is $200 per day) a show can be considered worthwhile financially. A *really* good show can yield several thousand dollars over four or five days.

Another way of judging a "good" show is to figure out what your "average" sale was. If it was $2, you assume that the public was not too serious and was only making impulse purchases. If it was $20 (depending on the price range of your work), you know the public was more serious about buying quality work. You might make the same amount of money at either show, but at the latter show, you obviously had a better market for your more complex work and would prefer it over the $2 average show.

Another useful indicator to figure is the ratio between the number of visitors to a show and the money you took in. This will tell whether people were buying or being entertained.

It is wise neither to rule out shows entirely nor to rely too much on them. This chapter is intended to help you deal with shows realistically and effectively.

If you're trying to get started, selling at shows is a good way to gain exposure. Shop-owners scout most nearby shows for new talent and will approach you if they like your work. It is also a good opportunity to see if the public will buy what you are making and at your prices. You will naturally benefit from talking with other craftsmen, learning about good shows or shops from them, getting ideas for displaying, pricing, etc., and talking over mutual concerns.

Even if you are not just getting started, there may be many reasons for selling through shows, not necessarily financial. Shows are fun—maybe the only kind of vacation you can afford to take. Getting together with a group of craftsmen for a couple of days or more is enjoyable. Usually it's fun for your children—especially if you're camping and if there are other craftsmen's children there and/or special activities for entertainment are available. Remember, most of these expenses are deductible for tax purposes.

As your hourly wage potential increases, the financial value of a show may tend to decrease—i.e., you might be better off to stay at home if you can sell all you can make at a later date. But shows are a good chance to gain exposure, to reassess what you are doing, and to gain incentive and stimulation from what

others are doing. This change of pace from production is necessary and rewarding occasionally.

For us, one show a month is more than enough. Some of our friends go almost every weekend during the summer months. Our production schedule is such that nothing would get done with that many interruptions. How often you go to shows depends on individual preferences and circumstances including:

The ease with which you can close up your studio and pack up your wares.

Your production-sales balance—if you can produce more than you can sell, or if you prefer to produce less and spend more time selling for about the same income, shows are desirable.

How much of a gambler you are.

Your location—if you live in the country, you may be more inclined to participate in shows than would a suburban craftsman who sells out of his studio and sees people all week.

The ease of setting up at shows—considerations of transportation and display.

Cost of setting up at shows—rent, insurance, production time lost.

If you enjoy meeting the public, benefit from feedback, and are a good salesman, you can (with some research) go to shows all year long now, and possibly make your entire living by selling at good shows. In actuality, it is a rare craftsman who does make a living from shows, because it becomes much less risky and much calmer to stay home and fill orders for shops part of the time.

Shows are very time-consuming for most. We lose at least the day before and the day after a show to packing and traveling. They are also very risky weatherwise. Rain can turn even a well-established outdoor show into a disaster for you.

They may also be conducive to selling mainly your lower-priced items, as has been mentioned. As craftsmen become established, especially production craftsmen who have developed a "line," they seem to prefer doing fewer shows and more selling through good shops or at their own studio.

TYPES OF SHOWS

There are many types of shows, and you will probably discover that you prefer to do certain types over others.

PROFESSIONAL SHOWS

There are "professional shows" put on by full-time promoters such as Jinx Harris, who organizes a show circuit and puts out a regular mailing; Pam Carson, who puts on the Boston-Philadelphia Flea Markets and the Colonial Antique and Crafts Show; Rudy Kowalzcyk of American Crafts Expo in Connecticut, who also puts on large craft shows on the East Coast from Williamsburg to Cape Cod. All these shows have relatively high entry fees ($40 to $100), as well as a gate fee for the public, but they are usually well-attended and probabilities are good that you will sell well if you have salable work. However, a word of caution—

there are less-than-scrupulous show promoters who charge high booth fees and do not spend them on advertising to get the public there. Stay away from this type, if you have any inkling that this might be true! (You might ask to see their books, showing expenses, after a show you felt was a rip-off.)

MALL SHOWS

Mall shows have a character of their own in that many of the people walking by are not necessarily craft-buyers, but mall-shoppers. Shop-owners may be annoyed by craftsmen when their own sales are lower. In an enclosed mall, you may have trouble setting up on a hard (carpeted) surface—you can't dig stakes in the way you can outside, etc. Another characteristic of mall shows appears to be that many customers will be more inclined to buy if Mastercharge or Bank Americard charges are available. An advantage of enclosed mall shows, of course, is that they can be held regardless of season or weather.

CHURCH OR ORGANIZATION BENEFIT SHOWS

Expenses for these may be lower, but make sure you are attending a craft show and not a bazaar (unless you want to attend a bazaar for some reason)—the buying public may be entirely different at this type of show.

COMBINATION CRAFT-ART OR CRAFT-ANTIQUE SHOWS

Your particular craft or style will determine whether or not you choose to participate in these shows. Our own experience has been that we sell very well at these, but we know others who don't. (Some of Pam Carson's "professional shows" are also antique and craft shows.)

CONSIGNMENT-TYPE SHOWS

Shows of this nature (such as the one held in Ithaca by the N.Y. State Craftsmen) do not require that craftsmen set up their own displays or be on hand to sell their wares. The time involved in these is therefore much less. They do, however, require a good deal of paperwork, because each item must be tagged with the name of the craftsman, serial number, and price. A corresponding sheet must also be filled out in triplicate, listing each item for sale. A show of this nature is rewarding in that it is usually very well-displayed by professionals. As in the case of Ithaca, it may also be juried, so that the quality of the work exhibited is usually high. On the other hand, this type of show can be somewhat frustrating to the public, who might prefer to meet the craftsman whose wares they are buying or who have to go through the whole show trying to isolate the work of an individual whose style they like.

It can also be frustrating to the craftsman who, because he is not present, has no control over how or even whether his work is displayed for sale. Because a show of this nature requires a good deal of volunteer help, the show can suffer

without enough of it; in our own experience, some items have been misplaced, lost, or never exhibited. The purpose of one item was misunderstood and so it was rejected. Thus, although some of our work was given awards from which we gained good exposure, in total we did a lot of paperwork for very little financial gain.

Although some shows, like Ithaca, are run entirely on a consignment basis, many shows have a consignment booth, along with the other craft booths, which they staff themselves. For a slightly higher commission they will sell your work for you if you cannot be present to sell your own.

PRESTIGE SHOWS

These are really exhibits, with less emphasis on selling and more on uniqueness or art. They are very valuable to establish credibility or a "name," but not directly useful for earning money usually. You may be invited to exhibit in other shows based on participation in this type of show.

There is a point-jury system which is commonly used to judge these shows. If there are three or four jurors, they rate your work on a scale of 1 (unacceptable) to 3 or 4 (outstanding). Scores are totaled; if the total possible is 12, the number 4 may be established as the rejection line (anything below it being rejected), and the number 10 as the special exhibit or court-of-honor line (anything above it will be placed in the court of honor).

WHOLESALE SHOWS

More of these are appearing on the scene each year. The American Crafts Council's show in Rhinebeck, the Southern Highlands, and the Maine Craftsmen's wholesale shows are three examples. The Rhinebeck Show is a wholesale show for two days during which you sell only to shop-owners, or take orders from them, and a retail show for the last three days. (The combination is more difficult than straight wholesale or straight retail, because you must set up for the duration of the show.) If you take on a wholesale show, it is important to have figured out your "line," your prices, and your production capacities. Whenever possible it is preferable to visit shops before deciding to do business with them, a policy that is impossible when you take orders impersonally at a wholesale show. If, however, you earn your living mainly from selling to shops, a large wholesale show may be very valuable to you. In reality, every show is a wholesale show in that shop-owners can visit them and make contact with you there.

OUTDOOR SUMMER SHOWS OR CRAFT FAIRS

The good outdoor craft show is an excellent medium for displaying one's work, realizing a financial gain, and acquiring exposure. It is also the one that is the most pleasurable for sellers and buyers.

One exhibitor at the Ann Arbor, Michigan Fair in the summer of 1973 reportedly took in $10,000, and another $8,000.

One of the most pleasant and longstanding summer craft fairs we have attended is the one put on by the League of New Hampshire Craftsmen at Sunapee State Park each year. As visitors in 1973 we enjoyed the atmosphere (calm), the size (under 100 craftsmen), the variety of quality functional crafts (especially the traditional New England crafts, such as blacksmithing, pewter, Shaker boxes, and baskets). Special features included a children's tent, where children could be left for an hour to paint or play with clay while their parents toured the fair; two demonstration tents, which included everything from the sheep right on up to the woven item and many other crafts; a puppet show, a fashion show of handcrafted wearing apparel, and a very interesting retrospect exhibit celebrating the fortieth anniversary of the show and lending depth and substance to the whole fair. Shade tents for resting, adequate parking, a shuttle bus, and availability of a central charge were additional conveniences for the spectator.

As craftsmen we felt that we would have enjoyed participating in the show, partly because a large buying public attended and partly because many extras were provided for the craftsmen, such as large tents giving equal protection from the elements to craftsmen and spectators alike, overnight facilities at a very reasonable rate, and a few social events; also booth fee and gate proceeds contributed to League services (although 30 percent is a very high booth fee).

TRADE SHOWS

These are very large shows held in major cities with extremely high booth rental fees. For most craftsmen they are not viable unless they produce a very large volume of work

JURIED SHOWS

Any of the previously mentioned shows can be juried shows, in which either the individual craftsman or each piece submitted is judged. A juried show tends to have somewhat higher-quality crafts, but it also tends to reflect the taste of the jury as to what "quality" is. It also tends to be conservative or "safe" in nature and have few surprises. A one-man juried show, unless it is just being juried for a court of honor, is especially problematical.

Often what is accepted or rejected says more about the jury than it does about the work of the craftsman. The craftsman should not alter his work just to please a jury—this is just as compromising as changing your style to please the buying public.

An unjuried show, although permitting a wider range of quality, lets the public do the jurying, in the sense that those craftsmen whose work does not sell will be discouraged from returning.

There are ways of raising quality without jurying a show. One is to set specific standards beforehand (no kits, no commercial molds, etc.). Another is to invite only people whose work has been seen at other shows—this may also be too limiting.

The advantage of an unjuried show is that the show directors do not imply that they are standing behind the taste or quality of each craftsman present.

There is, therefore, no confusion between their standards and those of each participating craftsman.

Juried shows are difficult and conducive to bad feelings and misunderstandings. Many juries end up leaving esthetic judgments aside and simply deciding in terms of adequate craftsmanship, which they may or may not be qualified to judge. If you have a bad experience with a jury or a show, it's best to try to ignore it and omit that show from your itinerary in the future.

There are as many different types of craft fairs as there are communities or organizations that care to put one on. They run the gamut from very local and very amateur to state- or regionwide and very professional. A show need not be big to be good, however. Somewhere within that range should be enough enjoyable and worthwhile ones for you to participate in.

Just as a good quality craft shop builds a clientele, a show will build a following over the years if it is well-run and offers good quality crafts. It is important to participate in and support those good shows, and not to sign up for poorly run shows with mediocre crafts. These hurt you and the craft market in general and don't deserve your presence or financial support.

DISCOVERING AND SELECTING SHOWS

HOW DO I FIND OUT ABOUT SHOWS— ESPECIALLY THE FIRST YEAR?

You can find out about local shows from newspapers, word-of-mouth, local church newsletters, etc. This is a good way to get started and you should try out a few of these local shows before taking on the larger and more professional shows. The next step is to ask other craftsmen you meet at shows, but be wary—a "good" show may mean a wide range of things and what's good for one may not be for you (see checklist on p. 58).

You can also check through newsletters from local or state craft organizations, as well as national craft magazines, such as *Craft Horizons* or *Artisan Crafts*. You can subscribe to show calendars, such as the one published quarterly on a national basis by Henry Niles.* You can even hire a booking agent. (This seems to be more prevalent in the West.) He will plan a craft tour for you over a period of six weeks or so.

Once you have been to a few shows, finding out about others seems to snowball automatically. People running shows get your name somehow, and you start receiving invitations from all over. Craftsmen at shows are usually willing to pass on names of shows. We like to encourage new quality craftsmen to sign up for good shows we've participated in—even other potters. It helps everyone in the long run—the shows, ourselves, and the other craftsmen.

*See Bibliography.

HOW DO I PICK THE RIGHT SHOWS?

There are three major elements to any good show—a good promoter, good quality craftsmen, and a serious buying public (in terms of both quantity and quality). Here is a checklist of things to consider in evaluating a show.

Have you attended this show in the past as a spectator? What were your reactions?

What is the entry fee or commission? (Is there a gate fee for the public?) Where will the proceeds go?

What is the past history of this show—how many people attended, what were the total sales and in what proportions (35 percent pottery, 10 percent leather, etc.)?

What do other craftsmen say about it? (Get more than one opinion and craft if possible.)

What crafts will be displayed there? How many in your craft? (Some crafts can tolerate a higher percentage than others.)

Is the show being held in an area where craft sales are generally good?

Consider traffic patterns, your booth location, lighting, adequate space—this information should be included in the promotional material sent to you.

Who is organizing the show? How well is publicity, etc. being handled?

How much traveling is involved for you? Shows away from home can be a good vacation. However, traveling to shows is expensive and time-consuming, so basically you should travel only if it is a time of year when you need to open new markets, or sales are slow in your area.

A state, regional, or national organization can provide a great service to craftsmen by compiling such a data sheet and acting as a clearinghouse for shows. (Midwest Selling Craftsmen is doing a questionnaire on craft fairs of this nature.) It can then mail them out on request to individuals desiring specific information or trying to evaluate a show.*

WHAT ARE THE CONDITIONS OF ENTRY INTO SHOWS?

Some are juried and will want to see slides or samples of your work. Occasionally they will accept you on the grounds that you have participated in a previous juried exhibit whose reputation they respect. These should be mentioned in a typed resume, which includes who you are and what you think your craft's interesting features are. You should also keep a set of a few good slides or snapshots of your work.

Friends of ours use plastic sheets to hold and protect their slides. These have twenty pockets for slides on a notebook-size plastic sheet—if ten slides are used there are ten adjacent spaces for labels, giving name, size, price, etc. This can be held up to the light and glanced at very easily by the show director. It will also be mailed back if you enclose a stamped self-addressed envelope and request that it be returned. (A slide sheet of this nature can also be used in place of a wholesale catalog and sent to shops interested in ordering from you. The obvious

*Leon Nigrosh, "The Craft Fair," *Craft Horizons,* American Crafts Council Publication (October 1972), p. 65.

advantage is that pictures can be added or deleted easily.) In addition to slides of your craft, it is good to have black-and-white photos of you at work in your studio. Show managers can use these in newspapers for advance promotion, and it is good publicity for you.

Rules of each show will vary—usually you are expected to stay the full time, sell your work yourself, and bring no pets. Some allow children, some do not; some allow extra lighting, some do not; all expect you to keep a neat and clean booth space and clean up after the show; some expect you to volunteer time. Whether stipulated or not, it is good to arrive on time (or early) and stay until the end (or late). You tend to have good sales in the first and last half- hours, especially if some of the other craftsmen are gone.

Also note that insurance for theft or damage to your work is rarely provided. If you have quite a bit of money tied up in the work you are taking to a particular show, check into getting your own insurance coverage for it (see the sample invitation on pp. 56-57).

DISPLAYS

If you have committed yourself to a show—for fun, exposure, feedback, or any number of other reasons—you will automatically be faced with the problem of displaying your wares effectively. The easiest but least effective way out is to accept the table the fair committee may have offered to provide; or, even worse, to bring a blanket and set up on the ground. These are both poor ideas for several reasons. Both arrangements are at a uniform height, too low to invite the customer to touch or closely inspect your work. Both look shoddy and unprofessional, and suggest that the quality of your work may follow suit.

A creative display that reflects your style and presents your work to its best advantage is a challenge and is as important as your craft itself.

Our first show was a local Antique and Crafts Show in which we agreed to participate at the last minute. The day before we were to take part (a bit late!) we sat down on the back steps to plan our display. It had to be

inexpensive; preferably constructed out of something we could find around the house.

fairly simple (we only had a few hours to design it and it had to go up and down quickly and easily before and after the show). It also had to be fairly lightweight.

versatile—not too large. We anticipated doing inside shows that winter and wanted to use the same structure again.

stable—we had heard about booths blowing over or getting pushed over by crowds.

suitable for displaying hanging pots (planters and candle holders) as well as having different height shelves for sitting things.

protected from sun and rain (both of which we had to the extreme the following day).

fairly simple and tailored with good texture (our pots are simple and functional).

able to support a sign telling who we were and where we were from. We liked the idea of doing a sign in our own medium eventually.

able to have lights attached for shows where electricity was available.

able to fit in our trailer

As we were pondering these criteria, our eyes lit on the children's swing set (a small one). We first checked with a neighbor to get a replacement (larger and nicer—the kids were satisfied). Then we dismantled theirs and went to work adapting it. The teeter-totter became a square around the top; we shortened the main crossbar so it would fit the length of the barn boards we had stored away in a shed. We cut off the legs to lower the whole thing slightly—which also helped it fit into the trailer a little better; we then bought a can of flat black paint and four bolts at the hardware store, and in about three hours and at very little expense we had a recycled, stable, very attractive and unique display. (See the photographs following p. 52.)

At a later date we added the awning—a piece of art canvas that tied to the top for shade and let down in back in case of rain—and a barn board sign by an art teacher friend, and some lights which were bolted to the front crossbar, when necessary. We've stopped a lot of people in their tracks by the uniqueness of the display, and it has been very effective, efficient, and serviceable in showing off our pots—mainly at waist-to-eye level where they can be touched. We've used it at both inside and outside shows where it fits all space requirements, and it is so stable that kids who recognize its original function can swing on the bars without budging it.

In designing your own display, think about the overall structure as well as the smaller units of display—have interesting contrasts of texture, color, space, etc. Here are some ideas for displaying various media we've seen. A trip to a good craft shop and a show or two should yield some ideas you can incorporate. Be careful not to use someone else's ideas directly; adapt and personalize them to your own style and needs. The most effective displays are original, simple, and functional; they reflect the individual craftsman's style and almost force the public to stop and look. Remember to bring all the tools you need for assembling these displays. Hammers, nails, saws, nuts, bolts, wrenches, tacks, tape pins, scissors, and string are often useful. (See the checklist on p. 58.)

STRUCTURES

These are basic forms which are stable, functional, and can be adapted to displaying different media in an average 10′ X 10′ space. Following are some examples.

A Modified Table

Boxes or pedestals at different heights to break up flat level surface—a branch or driftwood on it for hanging objects.

A table with a frame, upright, adjacent to it if you have items that need to be hung.

A table with a tripod (beside it) for hanging items like pots. (Figure 1).

Figure 1

A Pyramid or Triangular Shape

Here the wide base gives stability. Examples are:

Shelves and risers, like stadium bleachers (Figure 2).

A pyramid built with round, fiberboard packing boxes.* These are also functional for transporting pots, but the display is only good inside; rain would demolish it. It is also good for negative (open barrels) and positive (closed ends) space as a background (Figure 3).

Swing set with a square on top. Good for hanging pots from and also to suspend canvas awning from for protection from sun or rain, and as a plain backdrop to clarify background (Figure 4).

A dome as a dramatic and functional shape for a week-long show like Rhinebeck—too complex to put up and take down regularly; good opportunity for

*Display by Ron Burke, ACC—Northeast, Rhinebeck, 1973.

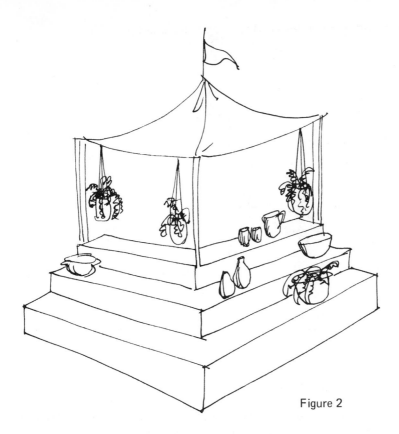

Figure 2

Figure 3

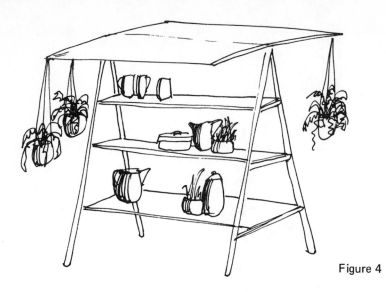

Figure 4

hanging; good weather protection when covered with plastic or scrounged parachute.

Rectangular Arrangements

Stacking—packing crates with barn boards on top: very simple to layer at different heights, effective as background to pottery, especially functional to carry pots when packed up (Figure 5); stacking interlocking boxes; stacking plexiglas cubes (Figure 6).

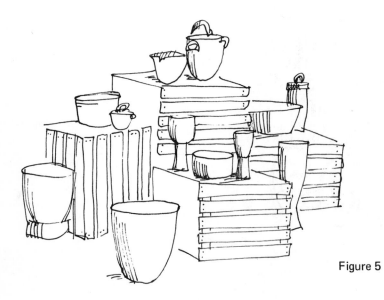

Figure 5

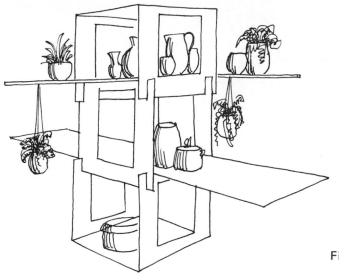

Figure 6

Modular frames with threaded pipes and elbows give modular spaces of different sizes and provide both hanging and sitting display potential; simple and effective—can be used with horizontal panels for pots or vertical dividers for fabrics or jewelry, or with trapezes hung at varying heights (dowel and filament) for displaying macrame or woven belts (Figure 7).

A combination of layered barn boards and supporting pipes.

Hinged cases (Figure 8).

Ladders in various arrangements—two tall stepladders facing each other with shelves supported by the steps; hinged ladders at different angles to have

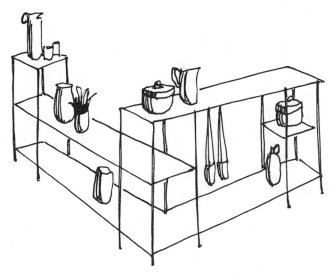

Figure 7

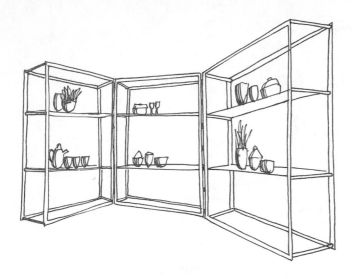

Figure 8

three-sided booth arrangement; a horizontal ladder on top of structure for hanging items.

Screens—hinged panels for backdrop to your booth can also be used to display from and create enclosed space (Figure 9).

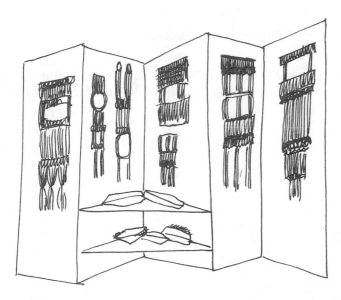

Figure 9

Shedlike or Cube-Shaped Booths

These tend to be more permanent in nature and hard to set up and break down for a one-day or inside show with limited space. They are easy to enclose and to cover for protection from the rain.

Unusual Structures

A horse-drawn carriage;

A trailer with a side door that opens up to expose your craft—styled after the traveling medicine man's display.

ARRANGEMENTS

Esthetics

Contrast in color, light, space, motion, and texture are all useful concepts, as indicated in the suggestions following:

Background texture—this can be obtained by using dried foods (coffee beans, lentils, pasta), bark chips, marble chips, gravel, fabrics (velvet, burlap), barn boards, cork, etc. Decide which ones are most appropriate for your craft.

Color—may be used effectively, but do not detract from your work.

Movement—a rotating watch or jewelry case can be effective, as can the natural movement of the wind.

Light—can be added in front (for pottery and jewelry) or from behind (stained glass) to highlight your work. Mirrors can also be used to give light interest. Sometimes lighted candles can be effective.

Space—think about negative and positive space. Vary heights by using pedestals, stacking boxes, hanging trapezes, etc. Use three dimensions. Have booth accessible from several angles if possible (Figure 10).

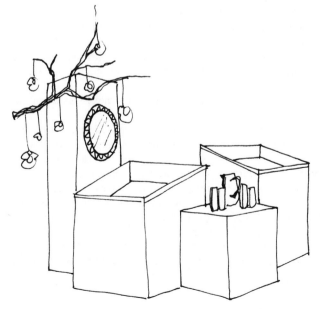

Figure 10

Function

Whenever possible, demonstrate the function of an object by your method of displaying it—use lights under lampshades, candles in chandeliers, napkins in napkin rings, plants in planters, cut flowers in a vase (this also adds color to your display), dried grasses in weed pots, logs on andirons, dried foods in storage containers, etc.

Function can also be labeled. Little signs dispersed throughout your display saying "cookie jars," "check-book holders," "baby's teething rings," etc., are very effective.

Items can be grouped according to function—all mugs together, all rings together, and so forth. This makes the display less confusing for your customers. If items are to be sold in sets, hitch them together—buttons sewn to cloth, mugs tied in groups of four by a leather thong, beads strung in dozen lots, for example.

Remember the public buying crafts does need visual aids. Your items may not be familiar to people, since crafts are not regularly advertised by the media.

Showmanship

Have a showpiece or a curiosity piece that will force people to stop and look and even talk.

Have a full display with a good price- and interest-range. (Predict quantities so your display remains full throughout the show if possible.)

Have individual tags on your work telling a customer who you are, how you made the object, and how he should care for it. Also include such information about the material content (all wool fiber, lead-free, etc.). These are not only informative, they add appeal if the item to be purchased is going to be a gift.

Use the work of other craftsmen in displaying your own, or wear somebody else's work. This arouses interest in both your work and his.

Consider having a "rummage around" section—a lot of one type of item that people can go through if they're interested.

Have personal pictures of you at work in your studio with captions. This often attracts great interest. A slide-tape presentation is a bit more complex, but can be very effective.

Demonstrate if you so wish—we talk about this in the next section of this chapter.

Any craftsman who has ever been a performer will realize immediately that there is an element of showmanship in setting up and selling at shows. A craft fair coming to town has much of the same atmosphere as that of a circus unpacking and setting up—it is a sort of magical instant transformation. Many of those attending craft fairs are in the frame of mind of an audience being entertained. You are the designer, producer, and main actor in your own little sideshow. If you can respond to this atmosphere and elicit a reaction from your audience—curiosity, laughter, applause, interest—you can probably capture its attention. Of course, the quality of your display and of your work is indispensable, but there is that additional interaction between you and the crowds which can be crucial.

Where to Find Display Materials

Scrounging is a very useful art, as is cleverness, in developing your display. Visit stores to see what display units they may be discarding; visit antique shops and auctions for interesting finds; comb your house for common items that can be put to use—ladders, screens, picture frames, shower curtain hooks, slide sorters, mirrors, jugs, branches, driftwood, wagon wheels, and countless other items. Your display, along with your personality, can have an overwhelming effect on your success in selling at a craft fair.

Ideas for Specific Media

JEWELRY. Have a mirror handy for people to admire themselves wearing your work; have signs indicating whether or not you are willing to size rings or change earrings from pierced to regular ear styles. Most people protect high-priced jewelry by cases or individual display units (black pedestals inside transparent photo cubes are very effective). Friends of ours claim they prefer to leave low-priced rings out for people to try on, but they watch the crowds very carefully. Two interesting displays we've seen recently have made use of a wooden barrel top to hang necklaces against and a background of lentils to exhibit silver items on.

SOFT GOODS. Hammocks are good containers for pillows or stuffed animals; cradles, chests, etc. are also effective containers. If you have woven ponchos, a hanging wicker bust is a good way to display them. Devising a change-room with hanging cloth space-dividers is useful, if you have clothing that should be tried on.

LEATHER. This looks good with antique props; good use can be made of large pieces of driftwood for draping belts, etc. Metal racks, such as those used in department stores, will hold a good selection of belts, wrist bands, key rings, etc., all at once.

STAINED GLASS. This needs light (and possibly movement). A picture frame covered with white grill-cloth is an effective display for pendants. Slide-sorters or frosted plastic over a light box can hold quite a variety of items effectively. Reflections of color from light above shining through to a surface below also have many possibilities.

PORCELAIN. An example of an excellent display at Rhinebeck (1973) was a booth by Pat Probst Gilman. It had both interesting variety and unity of style combined. Pat used texture in the form of an old lace tablecloth as a side space-divider, and an antique organ scroll for her sign. She used light effectively to set off her most interesting piece, an incised porcelain hanging lamp shade. This also emphasized its function, as did lacy ferns hanging gracefully from procelain planters. The full three dimensions of the booth were utilized. The public's interest was piqued by a shelf up front of miniature stoppered perfume

bottles which could not be resisted. The whole display reflected her delicate style in porcelain, as well as inviting the spectator to stop and participate.

DEMONSTRATING YOUR CRAFT AT A SHOW

There are some shows that either require demonstrations as a condition of entry or give you free booth space if you are willing to demonstrate. In these cases, go prepared to set up an interesting, professional-looking demonstration. Do not expect to show people everything; rather, include only aspects of your craft that the spectator will be able to understand easily and find interesting.

If the choice is yours, you should not demonstrate with the intention of thereby increasing your sales, because this does not often happen. You should make sure that a second person is with you to handle sales while you are demonstrating. At some shows, the demonstrations are in a separate area, so this is a necessity. Even if you are working at your own booth, you may attract so many people that it is more difficult for a serious customer to see your work through the crowds. You may also find that once the crowd clears, a few items will be missing if you are not careful. A second person is essential to handle customers and watch for rip-offs.

Demonstrating is good in the long run in that it educates the general public. The craft consumer has not been bombarded by TV commercials about crafts, and he rarely knows how various techniques are performed. A demonstration may lead him to develop an interest in a craft and buy something—then or later on—or to be more favorably disposed toward crafts in general. It may also lead him to go home and try it for himself and not buy anything at all.

In deciding whether or not to demonstrate, consider how much equipment is necessary, whether you can actually do productive work while demonstrating, and so on. Alternatives to demonstrating are to mount step-by-step photographs, with explanations of how you perform the various processes involved in making your finished pieces; or to run a slide-tape presentation of the same thing at intervals, to arouse interest.

HANDLING MONEY AT SHOWS

You should maintain retail prices on your work—do not inflate or deflate your prices for a particular show. Prices should be clearly marked on each item. In addition, your business tag will convey specific information as well as an image. Make sure that prices are visible on all items—those without price tags will not sell. Stick to the price that you have marked, even at the end of the day. Some customers expect that they can (or should) bargain with craftsmen to reduce their prices. It is important not to do this.

52 Make sure you bring a change box and plenty of change. You also need sales

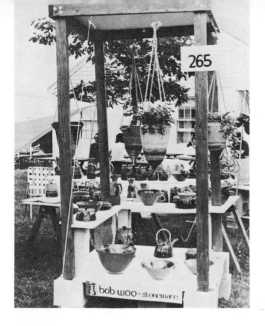

Bob Woo, stoneware display

Heise-Zack assemblages (Rhinebeck '73)

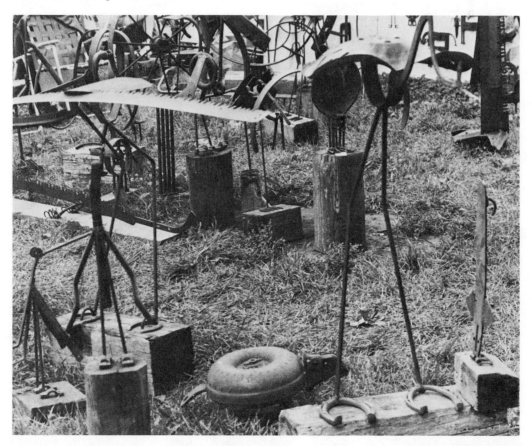

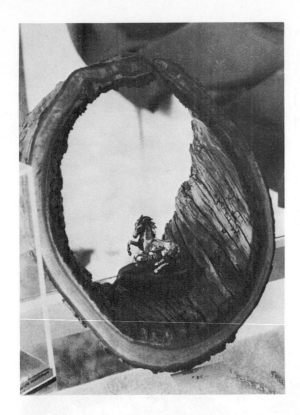

Metal display by Barbara and Bob Scarponi
(New Hampshire '73)

Woven forms, Carol Schwartzott

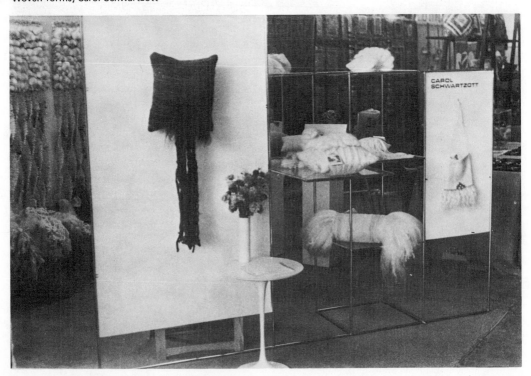

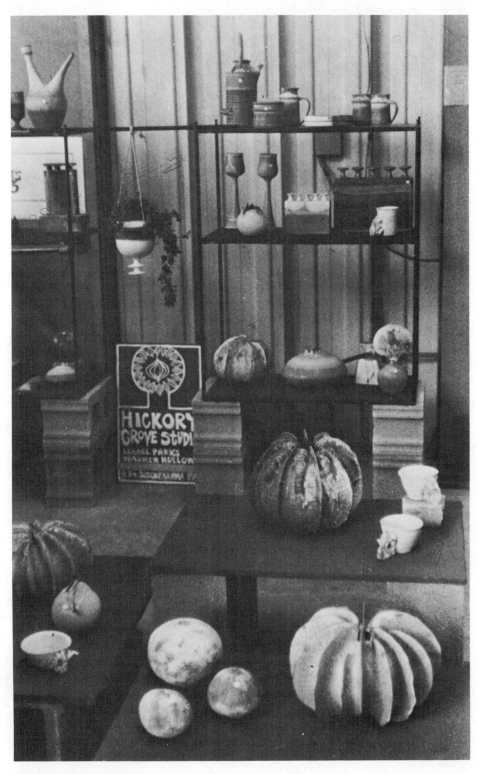

Sculptural forms and pottery
by Isabel Parks and Warren Hullow

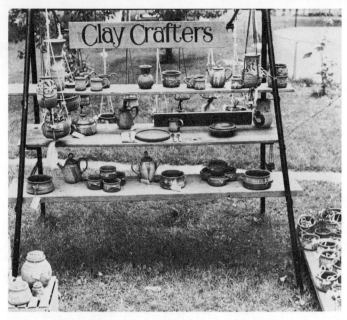

Pottery and display by the authors.

Pottery displayed on a swing set.

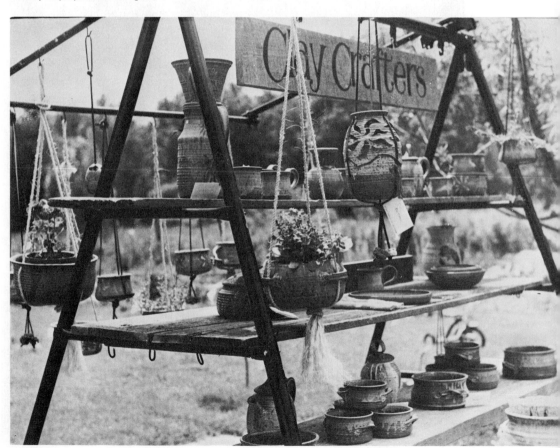

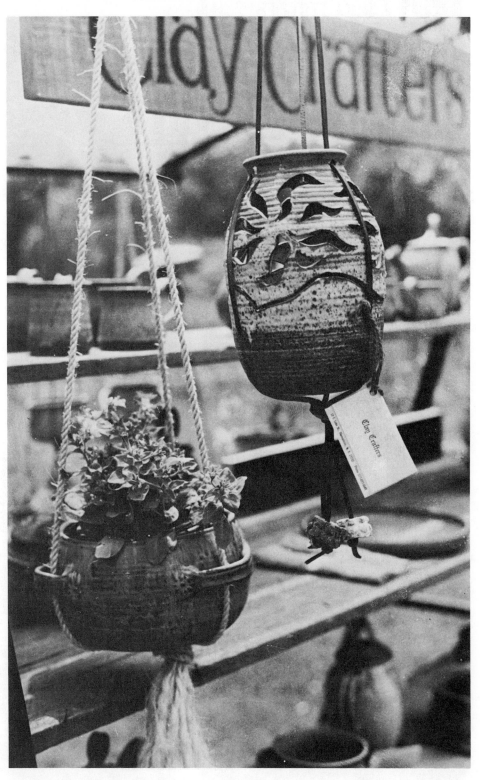

Close-up of planter, displayed with plant to show function,
and carved candle holder, showing individual tags.

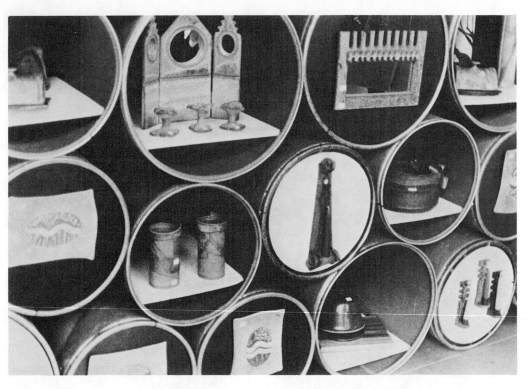

Pottery by Ron Burke

Silver jewelry by Nancy Barrett, displayed on handwoven background hung from an upright loom (New Hampshire '73)

Porcelain hanging lamp
(wheel-thrown, with incised design)
by Pat Probst Gilman

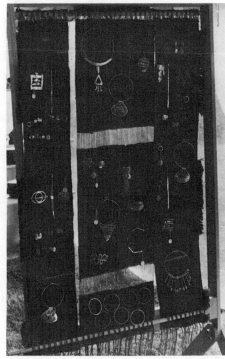

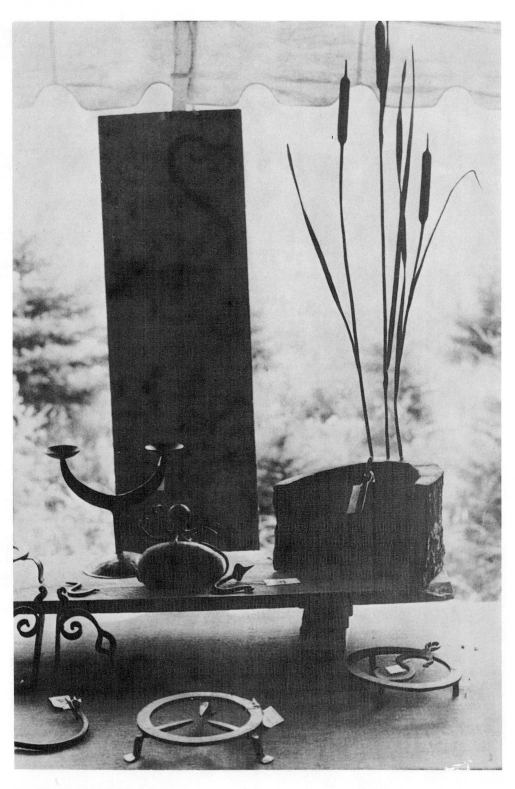

Forged iron by Ron Lewis
(New Hampshire League Fair '73)

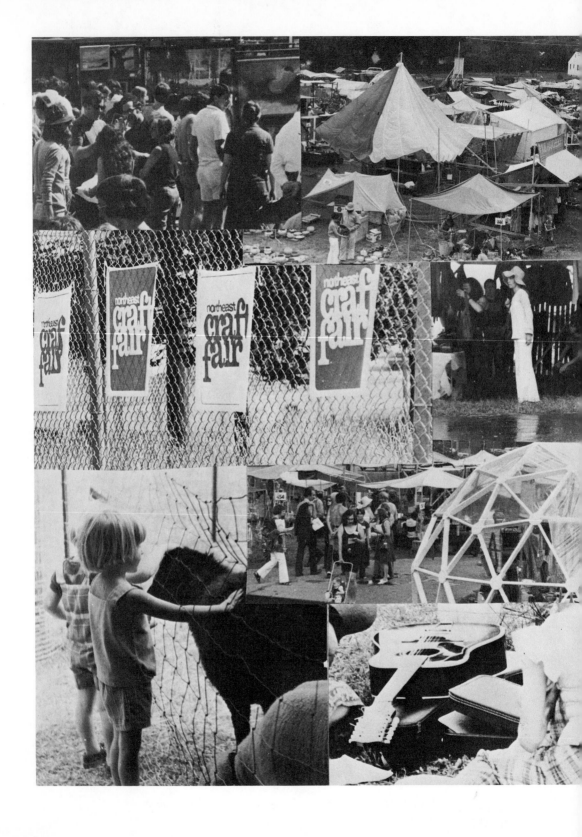

pads, or sheets of paper on which you list what you sold, in what quantity, and in what order. A good policy at a craft show is to take an inventory at the beginning and at the end of the day, then check it against your list and your cash box. This type of cross-check is a good way to figure out if anything is missing, and it is a quick and simple way to determine how much you sold and which items have been selling best.

It is also helpful to have a sales-tax chart beside your sales pad, indicating the correct percentage for that particular area. Show promoters often supply them. Make sure you collect sales tax if your state requires that you do so. Some craftsmen ignore it, which is not only unprofessional but illegal; and there are often "plain-clothes" buyers from the tax office checking on craftsmen at shows. It is also not right to absorb the tax and pay it yourself out of your profits. Again, consistency is important. At almost every fair we've attended, at least one customer has expressed surprise when we added sales tax to the purchase price of the item, claiming that he just bought something from a craftsman down the aisle and didn't have to pay sales tax. This is a poor situation and makes craftsmen look very amateur. People expect to pay sales tax on everything else—crafts should be no different.

When handling cash, have a large, heavy cash box which cannot be easily lifted—preferably divided into sections. If someone hands you a large bill, repeat the amount he owes you and the amount he gave you ("$2.50 out of $20"); keep the bill in sight while you are making change; count back the change and repeat the number of the bill again ("$2.50, $3, . . . $20"). If you repeat the amount of the bill three times, there is little room for confusion. Keep your large bills out of sight—in your billford—and notice the next time you're in a grocery store that the "ones" are closest to the customer. Also keep the bills in order and all face-up. If you handle money carelessly, you are a perfect target for the occasional unscrupulous person who chances to observe you.

We do accept checks. We ask for identification plus an address and a phone number. So far, we've received only one bad check, for about $6, and we've taken a lot of checks. One way of decreasing the risk of bad checks is to set up an account with a central charge company, such as Master Charge or Bankamericard. The 4 to 6 percent service charge will probably be balanced out, not only by decreased risk, but by increased sales as well. Some show managers set up a central courtesy booth where this is available to all participating craftsmen. Most promoters and craftsmen who subscribe to this service feel that it is definitely worthwhile. This is up to individual preferences, however, and may partly be influenced by the price range the craftsman's work is in, or the number of retail shows at which he sells.

When you return home after a show, copy the names and addresses from the checks of those who have spent, say, over $10. Take the names of those who pay you that amount in cash at the show. Then, if and when you decide to have an open house or studio sale, you will have a mailing list of those who like and have previously bought your work. This idea can be used *very* effectively and at minimal expense to you.

Collage of Craft Fair scenes

PUBLIC RELATIONS

TALKING WITH OTHER CRAFTSMEN

We have already mentioned that this is the best way to check out shows and shops you are interested in selling through; it is also a good way to talk over professional problems and possible solutions. Barter is often a possibility, if you like another craftsman's work and he will accept yours in exchange. Even if a show isn't too lucrative for you, you may come home with some treasures; and you will probably have had a good time.

TALKING WITH THE SHOW DIRECTORS

It is important to understand that they have problems too and try to be as cooperative as possible. They may be dealing with many hassles the average craftsman is unaware of—unions, public utilities, commissions, county ordinances on merchandising permits, etc., are a few that have been described to us, not to mention normal layout and promotional problems.

If you are displeased with something, find out all the facts and try to make constructive suggestions—do not wander around complaining. If you are pleased with the show, drop the show directors a line afterward, as well as mentioning it to them at the time, and tell them that you hope you'll be invited back. Most show directors or committees work very hard putting on a show and appreciate your support and encouragement.

TALKING WITH SHOP-OWNERS

Even at a show that is mainly open for retail selling, buyers for shops may approach you. It is a good idea to have wholesale lists and order forms with you if you have them. If not, you should know what your policies are on wholesaling, consigning, pricing, etc. and be able to discuss them with the buyers. We usually invite a shop-owner to visit our studio when he places his first order. This is less confusing than conducting business at the show, and it gives him a better idea of who we are and what our production capacities are. We then try to deliver the first order to him in person, so we can visit his shop and see how our work will fit in.

Occasionally, a buyer will offer to come back half an hour before the show ends and select from (or take all) the remaining items. This saves you packing them up and taking them home, but it may leave him with a poor selection. If this is the case, you should avoid it. Our personal policy is to refuse to consign altogether. If you do agree to consign, though, make sure you go to the shop **54** yourself—don't do it from your booth at a show.

Craftsmen who are good at this and enjoy it usually continue selling at shows. Craftsmen who are poor at dealing with people should bring along someone who can do it, or not try to sell through shows at all.

There is sometimes a tendency among craftsmen to protect their own egos by scorning the taste or intelligence of the average buying public. Most craftsmen of longstanding, however, tend to gain renewed respect for the public. (After all, some of their best friends are customers.) At any rate, do not treat people in a condescending fashion. For whatever reason they are buying your work, they are enabling you to continue doing what you want to do and living the way you choose.

"Psyching out" whether someone will buy and what they will buy is challenging entertainment for the craftsman selling at a show. It has been our experience that women often are interested in discussing new or appropriate ways an item can be used (Nancy talks with them), and men are more inclined to talk technically about how the item is made (George handles this). High-pressure approaches are always to be avoided, but your friendliness and readiness to talk should be evident to the public. Selling requires sensitivity to the individual buyer and is an interesting art in itself.

At one of the early shows we attended, Nancy made the mistake of apologizing to a customer because the price of an item seemed "high" (it was more than *we* could have afforded); the woman gave her an astonished look, declared that $10 wasn't very much, and that this was exactly what she needed for her gazebo. Whereupon we formulated principle 1: Never apologize about price—someone may have exactly the right gazebo for your candle holder.

We have often reformulated principle 2, which is not to listen to what you are not intended to overhear. But it is so tempting that we always end up breaking the rule. At one show, a lady glanced at our work, came over and picked up a mug, appeared to seriously consider purchasing it, and then put it down and walked away, saying before she was quite out of earshot, "My house is so contemporary, pottery would just seem out of place. I'd have to change my whole life-style if I bought those mugs." We never did add that up completely.

This summer, while our apprentice was minding the booth she was amused to overhear a couple of middle-aged women discussing whether or not one of them should buy a hanging planter. One friend was trying to convince the other that it would look really nice in her kitchen window and cheer her up when she was doing the dishes. Then she remembered that Mabel had a maid and never had to do her own dishes—and away they went, empty-handed.

There are always the people who find your work too dull, too expensive, too ordinary, too far-out, etc., in stage whispers; there are many who could do it themselves or have a close relation who does exactly the same thing and would give them one for nothing. People seem to need a reason not to buy, as well as to buy. But then, when it looks as if the whole crowd has talented relatives, someone will stop and love what you're doing and buy something. And you feel better again.

ANALYZING THE SHOW AFTERWARDS—FEEDBACK

It is very easy to become depressed after you have sold poorly at a show, especially if those around you did considerably better. It is therefore desirable to be rational, try to determine the cause, and try to avoid the same pitfalls a second time.

If the show was poorly publicized and few attended, or if those who attended came to look and not to buy, probably nobody did too well. If, however, your location was poor, your light was poor, your display was not attractive enough, your prices were not in the range people were spending in, you had too much competition in your field, or your attitude was poor, you may be able to explain your lack of success.

If you sold well, try to be analytical after the elation dies off. Which items sold particularly well? Can you use this to predict proportions—how many items at what prices—for the next show? (There is a danger here to be tempted to make what people are buying instead of what you really want to make.)

Shows, in general, tend to sell low-priced impulse-buying types of items. In fact, as we mentioned before, the seriousness of a show can be judged by the price range your objects sell in. If you do get hooked on the show circuit, especially the less serious shows, you may discover that you are making a living, but you are no longer doing the type of work you had intended to do. Perhaps you would be better off selling through galleries, which attract a different buying public. This is a question for each craftsman to consider. Financial success at shows may end up limiting professional growth over the long run—or it may not.

SAMPLE INVITATION

[This is a composite of many different invitations.]

Dear Exhibitor:

The ABC Craftsmen will sponsor their fifth annual Spring Crafts Show at the Exhibition Building of the City Fairgrounds, Big Deal, Mass., on Saturday and Sunday, April 6 and 7, 1974. The hours will be Saturday from 10 A.M. to 8 P.M. and Sunday from 12 noon to 6 P.M. Wholesalers are invited to attend from 10:00 A.M. to 12:00 noon on Sunday.

Set-up for craftsmen starts Saturday morning at 7:00 A.M.. All must be ready by 9:45 so the committee can view the show to select work for the special exhibit. Carts and assistants will be available to help in unloading and setting up. Cars must be moved immediately after unloading—adequate free parking will be available for all. Relief will also be available during the show for those who would like to take a break. A refreshment stand will be on hand, and free coffee and donuts will be served during set-up. Almost unlimited overnight accommo-

dations are available within a ten-mile radius. There will be a social hour with free beer for all exhibitors after closing Saturday night.

The show will be limited to 75 of the area's finest artists and craftsmen, and we are hoping that you will be able to join us. Craftsmen who have not exhibited in one of our prior shows are requested to submit two photographs of their work with their application form. Applications will be accepted on a first-come, first-served basis, unless one craft exceeds either 10 percent of the participating crafts or seven in each media.

Registration is $25 for the two days (no commission will be charged). Exhibitors must remain for both days of the show. Space will measure 10' X 10'. All money received from registration will be used for advertising, rental, security, etc. The public's $1 entrance fee will go mainly toward two craft seminars we are planning to hold this fall. Exhibitors should bring all their own display materials, including chairs, backdrop, display stands, etc. Tables will be supplied if requested in advance. There will be security on hand throughout the show hours, including Saturday night. However, any loss or damage to exhibitors' work is the responsibility of the exhibitors, not of ABC Craftsmen. Electricity will be supplied if requested on application. Craftsmen are encouraged to demonstrate, and electricity will be provided for this purpose at our expense.

Exhibitors must agree to the following conditions. Failure to do so will mean automatic removal from this and future shows. The committee reserves the right to reject any work which, in its judgment, might be objectionable to the general public.

1. *Craftsmen must exhibit original works only—no imports, patterns, commercial molds, kits, or dealers.*
2. *Craftsmen must sell their own work.*
3. *Space may not be shared unless approved beforehand. Request to share space should be noted on the application.*
4. *All work exhibited must be for sale.*
5. *No animals are allowed.*
6. *Craftsmen must remain set up for the entire show.*
7. *Booth space is nontransferable.*

Fill out the application and return it by March 15 with your registration fee. (Make checks payable to ABC Craftsmen.) Indicate whether you would like last year's space again this year. No refunds for cancellations will be made after March 25. The response by exhibitors to our previous shows has been great, and we recommend you return your entry form as soon as possible. Last year's attendance by the public exceeded 10,000 with sales of over $20,000. We expect this year's show to be better than ever, and we look forward to your participation.

Sincerely,

ENTRY FORM—ABC CRAFTSMEN'S SPRING SHOW 1974

Entry into this show constitutes an agreement that the exhibitor will take no legal action against the director or his agents for loss, damage of work, personal property, or personal injuries. I understand the conditions of entry and agree to honor them.

**Selling
at Shows**

Name_____ Craft _____

Address _____ Zip _____

Phone _____ Space requested _____

If exhibiting for the first time, have you enclosed two pictures of your work? _____

Will you need electricity? _____ A table? _____

If sharing booth, please explain with whom. _____

Signature _____ Date _____

Please return to ABC Craftsmen, with your full remittance, Box 1234, Big Deal, Mass. 01234. Enclose self-addressed, stamped envelope for our reply. Thank you.

CHECKLIST BEFORE LEAVING FOR A SHOW

Think About:

☐ YOUR WARES. Has everything been priced and packed? Have you included props for showing function?

☐ YOUR DISPLAY STRUCTURE. Also tools for construction.

☐ YOUR OFFICE SUPPLIES. Sales pads, change box, change, business cards, order forms, clip-board, pens, pencils, pins, scissors, tape, string, bags, boxes, extra wrapping material, etc.

☐ PROTECTION FROM THE ELEMENTS. Rain gear, hats, awnings for shade, sunglasses, sweaters, etc.

☐ FOOD AND OVERNIGHT SUPPLIES. Cooler, thermos, tents, sleeping bags, etc.

☐ SOMETHING TO DO. Entertainment for kids if going; fun or work for you to do at slow times of show.

☐ INSURANCE.

☐ INSTRUCTIONS. Did the fair committee send special materials? A map?

5 Selling Through Shops

Some craftsmen have expressed to us a philosophy that shops are a rip-off, and say that they intend to sell all their work themselves. This type of craftsman is basically unaware both of his own limitations and the importance of craft shops.

First of all, there is much less risk (of rain, poor attendance, etc.) in dealing with a shop rather than a show. Shops, therefore, lend overall stability to the craft market. Shops are also important in that they keep a selection of good quality crafts before the public constantly—not just on the occasional weekend that a show pops up. Not only do they select according to their concept of quality and salability, they display items well in an interesting and hopefully uncluttered manner. There are many people who have money and want to buy crafts who do not trust their own taste to find a quality piece in a chaotic unjuried show—these people rely on the taste and knowledge of the shop-owner.

Most craft shops are not making a great deal of profit—less than a normal merchandise store, in general. The craft-shop owner usually is in this business because he is excited by crafts and believes in promoting them. Shop overhead can be quite high—salaries, rent, insurance, taxes, heat, utilities, special boxes, and advertising, to mention only a few expenses. Many shops even have trouble making ends meet with a 100 percent markup (doubling your wholesale price).

Craft shops are rarely a rip-off. The proportion of the work you sell through shops is up to you. Individual preferences vary. But to rule them out entirely is foolhardy.

DEFINITIONS

Here are some terms you will need to understand when dealing with shop-owners.

SELLING ON CONSIGNMENT. Placing your goods in a retail outlet (shop) with an agreement that you will be paid only after your items have sold. This is a practice almost unique to the arts and crafts field, and it has many disadvantages.

SELLING WHOLESALE. The shop buys your work outright at a discount (30 to 50 percent) from the retail price and pays within a given period (30 days) whether your work has sold or not. This is a preferable way of doing business.

GUARANTEED SALES. A less widespread policy, but very effective. It is similar to consignment but leaves you in control. You sell your work outright but agree to exchange pieces that have not sold over a specified period of time at a specified price, provided they are returned in good condition.

WHOLESALE SELLING: CONSIGNMENT VS. OUTRIGHT

Whenever possible, do not consign; sell outright. Here are some reasons why. When you sell outright

there is less bookkeeping.
there is less "policing" of shops to make sure they are displaying your work well, if at all.
there is less danger of not being paid on time or of having work returned in damaged condition.
there is less danger of a shop going bankrupt if it has enough money to invest in your work.
there is more incentive on the part of the shop-owner to sell your work if he has his money tied up in it.

The retailer's profit margin takes care of both his risk factor and his money being tied up. The craftsman should not be expected to tie up his money (work) and to accept the risk of its not selling—especially since he has little control over whether it sells or not. Selling outright is the more professional way of doing business, the way it is done in almost all other types of business, and the only way for the craftsman to maintain control.

Consignment may be viable in certain instances:

If a prestige shop does nothing but consign (we have consigned to a local museum gallery).

if you are just getting started (we have done this to gain exposure).

if you know a shop to be reliable and it is close enough to visit regularly; also if it has a high turnover rate and a lower than normal 33 1/3 percent commission.

if a gallery with potential is just getting started and will switch to buying outright within a short period of time.

if a local service organization which you would like to support is running the shop.

Although you have less control, there are two advantages to consigning to reliable and local shops. One is that they will take whatever pieces you care to give them rather than only the work they've ordered. The second is that you make a little more money if your rate of commission is lower than your wholesale discount. (It is actually more advantageous to the shops to buy outright because they will make more money for themselves with the higher wholesale discount.) When consigning, you also have the option of retrieving work from the shop to take to a show and then of returning it to the shop if it hasn't sold for you. (This should be done with restraint—it involves a lot of paperwork.)

There are some wholesale methods of selling that seem to be compromises between the outright and consignment ideas. We have already mentioned guaranteed sales, which we practice ourselves and recommend highly.

Some shops that mainly deal on a consignment basis are beginning now to buy outright some items—production items which turn over fairly rapidly—and consigning others—the one-of-a-kind slower-turnover items. In other words, they carry two accounts, an outright and a consignment one, with the same craftsman. The New Hampshire League has begun to do this, as has a local museum gallery with which we do business. This works very well at peak times, such as Christmas, because it enables the shops to order ahead and not be caught empty-handed, especially on the high turnover items.

A rental arrangement is being practiced in some places as an alternative to consignment. A shop rents out space to a number of craftsmen at a fixed rate (say $15 per month). This can be advantageous to both. If the craftsman's work sells well, he can sell a large quantity for the same fixed price. The shop-owner takes in a certain amount of rent per month regardless of the amount he sells. This sounds as if it might work out very nicely on both sides; we personally have not had first-hand experience with this type of arrangement.

Neither have we had experience with another method known as the "memo" shipment, which has been common in the jewelry trade. A shop receives a shipment of work with a memo. This means that at the end of a period of time (normally 30 days), the owner can pay for everything and keep it all, pay for what he has sold and return the rest, or return it all, if nothing has sold.

Whenever possible, we prefer to retail sell our own work—either out of our studio or at a few good shows. Retail sales account for about half our business. We wholesale, with a guaranteed sales policy, regularly to a few good shops, but we try not to sell wholesale what we could have sold retail ourselves. In the past, we consigned to two shops to get ourselves started, but both have now switched to ordering and buying outright from us.

CONSIGNMENT SELLING

If you do consign, choose your shops carefully. We know of no one who, at one time or another, has not had trouble when consigning. Write up a consignment agreement (see sample shown below) and have your lawyer check it. You cannot always count on the shop to have one, or one that you are willing to sign. Ask the shop-owner to sign yours, or his and sign it yourself (if it is his, ask to have your lawyer check it first).

Be prepared to do some paperwork: your price tags, showing retail price, should also include your name and the number of the item. (Start with 1 and keep a consecutive count going on following orders.) You then should fill out a dated invoice sheet (in duplicate) with the same information—number of item, description of item, retail price, and a column to check whether it was sold or returned. Make sure you check these off each month when you receive your statement and your check, minus their commission.

Relations become strained easily in a consignment situation, especially if the craftsman's work is not selling well or he isn't being paid on time. Damaged work can also be a problem. Although a store is responsible for returning your work in good condition, it is sometimes difficult to collect your money on items that have been damaged or stolen. If this happens, it is best to pull out (a right which is understood, but should be specified in your agreement).

Note: for tax purposes, work on consignment is still considered part of your inventory, and your property.

RULES FOR CONSIGNMENT (Sample Shop Agreement)

1. Articles may be brought for consignment at any time during shop hours. Shipping will be at the expense of the craftsman.

2. Only articles in good condition will be accepted. Acceptability depends on quality of workmanship, design, realistic price, and salability.

3. Checks covering all items sold for consignors during a calendar month will be mailed during the first week of the following month.

4. Both consignor (craftsman) and consignee (shop) have the option to either return or request return of articles if unsold after 60 days at their respective expense.

5. Articles consigned to the shop will be the shop's responsibility once received—for breakage, fire, theft, etc. Payment will be made to consignor for any articles sold or not returned.

6. The shop's commission on articles is one-third the actual selling price. No charge will be made for articles that do not sell.

I have read the above rules and agree to accept them as applicable to all articles left on consignment for sale.

_____ _____
(Consignor's signature) (Date)

_____ _____
(Consignee's signature) (Date)

SELLING OUTRIGHT

Here are some useful terms and definitions if you are selling wholesale to shops:

2/10/30. A common practice observed among gift shops, although generally not by craftsmen. It means that if the shops pay their bill within 10 days, they expect a 2 percent discount. They must pay their total invoice within 30 days.

F.O.B. Stands for Free (or Freight) on Board. This means that the buyer pays shipping from the place specified; pottery shipped F.O.B. Skaneateles means that the shop pays the shipping fee from Skaneateles to its location.

C.O.D. Stands for Cash on Delivery. This means that the buyer must pay the postal agent for the merchandise before it can be delivered. (This may be very inconvenient if the person minding the shop at the time of delivery is not authorized to write checks.)

E.O.M. Some terms specify End of the Month payment. In this case, of course, they prefer delivery at the beginning of the month so they will have almost 30 days in which to pay.

PRO FORMA. If an account is new or has no credit credentials, it is wise to ask them to remit full payment before you ship the work they have ordered. This is selling on a "pro forma" basis. If you have to make up a special order, it is also wise to ask for a 50 percent deposit before you begin work on the order and the remaining 50 percent before you ship it.

MARK-UP. The percentage a shop *adds* to the amount it pays for the work (the *wholesale* price) to determine the retail price. A 100 percent mark-up means that a shop doubles the wholesale price and receives, for example, $10 (retail) for an item it paid you $5 (wholesale) for.

DISCOUNT. The percentage a shop *subtracts* from the *retail* price of the work to arrive at what it pays you, or the wholesale price. A 50 percent discount is the same as a 100 percent mark-up.

INVOICES, PACKING SLIPS, AND STATEMENTS. Standard forms you can

purchase at an office supply store. You should also think about having your name, address, and logo imprinted on them at some point to help create an image for yourself.

When you pack an order and ship or deliver it to a customer, you will itemize what is in each box on the *packing slip*. It will include your name and address, the date, the terms of payment, and the name of the customer. One of these goes in each box.

An *invoice* is similar except that it lists the whole order and is not packed in the box. You mail it directly to the buyer, first class.

A *statement* is usually not an itemized list—it is simply a bill sent at the end of the month that indicates that the store owes you a certain amount of money. Many stores will automatically pay you 30 days from when they receive the shipment, or earlier, and you may not need to send a statement at all.

Statements, invoices, and packing slips are all done in duplicate (or sometimes triplicate) so that you have one copy for your records. The larger and more impersonal the store, the more important these forms become in conducting your transactions and receiving payment.

Paperwork is as important in wholesale selling as it is in selling on consignment. You should develop a price list and an order sheet for your production items. We are now assuming that you have developed a "line" of six or eight items in various sizes, colors, and styles, that you can produce efficiently. They may be coordinated (related in function such as various dinnerware items or items of wearing apparel) or they may not. On your order sheet, you should specify your discount and your terms of payment. Also state whether packing fees are charged, as well as mailing or delivery charges. If you require a certain minimum order ($50 to $500), so state. It is illegal not to give the same terms to everyone in the same location at the same time.

If you do quite a bit of wholesale selling, some sort of catalog or picture sheet is a necessity. Sometimes line drawings suffice on a price list. A catalog is expensive and may have to be updated frequently. A plastic slide-sheet, as we mentioned in the chapter on shows, can be changed at will and is just as effective. (Shop-owners might consider having the same type of slide-sheet to show craftsmen, especially if they are meeting them at a wholesale show and the craftsmen have not seen the shop.)

Make it clear to the shop-owner, in your catalog or on your order sheet, that there will be variations in size, shape, and color natural to hand-made work, but that the quality will be the same as that which they have seen before placing their order.

We also encourage orders to be as open-ended as possible: one dozen X's, assorted colors, styles, and price range. Some shops who have done business with us for a while will even give us total freedom—"$400 wholesale order before November 1—we'll leave the selection up to you. Anything you give us sells well." This is terrific for the craftsman, obviously.

SAMPLE WHOLESALE TERMS

NEW ACCOUNTS. *$100 minimum order; please prepay or give the names and addresses of three craftsmen you do business with.*

ESTABLISHED ACCOUNTS. *$50 minimum [minimums are retail value]. Each order must be paid in full before additional orders will be filled. If not paid within 30 days, next order must be prepaid.*

DISCOUNTS. *40 % discount on all orders over $200 (retail) 35% discount on all orders of $50 to $200. No wholesale discount under $50.*

DELIVERY. *Normally 4 to 6 weeks, F.O.B. Skaneateles, N.Y. by UPS.*

PACKING AND SHIPPING. *Packing charge 5% of invoice. All orders are carefully inspected and packed in good condition. Reports of damaged goods should be made to us within 5 days of receipt of shipment.*

NOTE. *If we should decide to deliver your order in person, we will charge only the packing fee (5% of invoice) and no postage.*
Variations in color and size normal with hand-made items should be expected.

GUARANTEED SALES. *If an item has been marked at no higher than our suggested retail price for 90 days and has not sold, and if it is returned to us in good condition, credit for the work will be applied to your next order.*

[This is not a legal document, just samples of the types of things that might be included in the wholesale agreement that you draw up and check with your attorney.]

ON RELIABILITY AND RELATIONSHIPS

In selecting the shops you sell through, some of the same criteria should be applied as in selecting good shows at which to sell. If you have a choice, select shops that carry hand-crafted items exclusively or predominantly. A gift shop, in many instances, is not the best place to sell crafts. We also prefer to sell through shops that carry a range of our work and not just one particular item. It is too easy for the public visiting the shop to assume that the one item they see for sale is the only thing you do. This type of misrepresentation can do serious damage to your image.

Be realistic about not dealing with too many shops. Do not accept more orders than you can fill and still maintain the same quality workmanship. Two **65** or three good shops may be sufficient, if you are doing some selling out of your

studio or at shows. Because reorders from your regular shops should have priority over orders from new shops, try to estimate them as accurately as possible. Also ask the shop-owner to help you in this and to order as far in advance as he can. Some shops will even put in an order for the entire year and then stipulate so much in two months, so much in four, etc. This can only be done if you have been working together for a period of time.

If you do go to wholesale shows, such as Rhinebeck or Sourthern Highlands, do not be afraid to put up signs saying "no more wholesale orders" or "no new accounts" on your booth. It is extremely poor to accept more orders than you can fill and leave the shop-owner hanging at a busy season, such as Christmas. It is actually illegal to take orders in writing and then not fill them.

It is also not a good policy to accept too many orders from shops in the same geographical location. Craft shops depend on their uniqueness as a selling factor. Their customers will not appreciate seeing similar pieces of your work at three shops in the same neighborhood.

There are pros and cons to the policy of giving "exclusives." This can be one way of getting a shop-owner to sell your goods initially. You should discuss with him what competition he will eliminate—if you agree not to sell to anybody else in the area, he should agree not to sell anybody else's leather bags, woven hangings, etc. The shop may be more strongly motivated to promote your work, and, sometimes as part of the exclusive agreement, they will even do some advertising promotion for your work.

Some craftsmen feel they are giving up control to agree to an exclusive. However, they can partially overcome this by stipulating in the agreement a minimum volume per season (money or pieces). If you should misjudge the shop or the owner and feel that you wish to discontinue selling to him—because the shop ignores you and does not promote your work, alters your prices to the extreme, or you cannot supply the volume they need—you can do this. The best way of setting up an exclusive agreement is to have a written contract (again, consult your attorney) which includes provisions for termination of the agreement.

Because the relationship between the shop-owner and the craftsman is of major importance, it is a good idea for each of you to visit each other whenever possible. This can alleviate some of the packing and shipping hassles as well. If you take time to visit your shops, you may be able to make suggestions to them—you may feel they should use a dust cloth more often, display something differently, or promote something you find especially interesting. They may even need a particular craft, and you may know a fellow craftsman's work that would fit in the store very well. Shop-owners appreciate your helpfulness if it is offered constructively.

At the same time, if the shop-owner can take the time to visit your studio, he can see what your individual problems and capacities are. This will help him comment constructively to you (feedback again). He might suggest a new idea; he might gain a better feeling for how far ahead he should order and what your production abilities will be; and he will definitely acquire more first-hand knowl-

edge of you and your studio to impart to his customers when he is trying to promote your work. Because this first-hand knowledge is so important, some craftsmen even go to the expense of printing up brochures and photo essays for shop-owners. These can be displayed prominently with the craftsman's work and give the customer a greater feeling of personal contact with the individual whose work he is buying.

All hand-made work should be signed—permanently. It is also helpful to the shop-owner and the customer if your work carries a special tag indicating how, why, and by whom the item is made, how it should be cared for, that it contains no harmful or toxic materials, etc. It should above all be attractive and convey the right image. Some labeling is now required by law (see Chapter 2); even if it is not, it is very worthwhile advertising to have at least your name and address on the item. It also makes your work look more professional, more individualized, and more appealing as a gift for someone else. Very often people will see our tags in a shop and call or visit us directly at a later date. Although the tags were expensive, they have paid for themselves many times over.

PACKING AND SHIPPING

Packing and shipping are a nuisance for many craftsmen. Potters and glass blowers find it especially disagreeable, and some even go so far as to avoid all shipping by doing their own delivering or requiring that their work be picked up at their studios. This may be a bit unrealistic, but understandable.

One of the best ways of packing large fragile items such as pottery or glass is by using excelsior or straw inside round fiberboard containers. Stained glass or small fragile items work well wrapped in bubble paper or straw, packed in individual boxes, and then insulated and packed together in a larger carton. The American Crafts Council's publication, "Of Exhibitions; the Why, How and Wherefore," has some good suggestions in it for packing and shipping various media.* It also lists comparative rates for various methods—UPS, REA, Parcel Post, etc. If packing is a problem for you, it would be helpful to read it over.

Remember, when you are packing and shipping your work, to have an itemized packing slip for each box you mail as well as an invoice which you mail separately to the shop. Keep the duplicate copies for your own records. If you do have breakage claims, you will need these for substantiation. These claims should be reported to you as soon as possible after the damaged shipment arrives at the shop. In most cases, it is you, the shipper, who will have to initiate the claim.

If you deliver in person or have someone drop off work for you, get a signature and a date indicating when and by whom the items were received. This is important to keep with your records.

*Elaine Koretsky and Berni Gorski, American Crafts Council Northeast, June 1970.

WHAT HAPPENS IF . . .

. . . A Shop-Owner Doesn't Discover You at a Show?

You go about finding and setting up the right shops largely the same way you find and evaluate shows—by ads in professional magazines, word-of-mouth from other craftsmen, or just happening across them. It is best to visit the shops just to look, first; then, if you think your work will go well, make an appointment by phone to set up a convenient time to come and talk with the shop-owner. This is much preferable to suddenly appearing on the scene and expecting him to drop everything to look at samples of your work. Be considerate and professional from the outset. If he doesn't want to order any of your work, try not to crumble; find out why—it may be that he doesn't have a market for that type of item, he already has enough of your medium in his shop, your work is not in the price range his customers buy in, etc. Respect his judgment and accept his comments for what they are worth. Maybe you can contact him again later.

. . . You Decide to Sell to a Department Store?

Large department stores usually have buyers for individual departments, making it more like talking to a small shop-owner. This will work the same way, essentially, as selling to shops, but always wholesale, no consignment. Make sure you fill out the proper packing slips and invoices, or the store will have trouble processing you and paying for the goods.

There are two reasons we prefer not to deal with department stores. We do not feel the same commitment to supporting them that we do to small (somewhat educational) shops; they are big and impersonal, and this is not what crafts are all about. Also, from our experience, people *buying* handcrafts do not tend to look first in department stores.

. . . You Do Not Get Paid by Someone?

If you are dealing with a shop for the first time, there are several things you can do to protect yourself from nonpayment. An ounce of prevention is important here—if you have to sue to get your money, it is expensive and unpleasant and should only be used as a last resort. Here are some suggestions:

Some shops are rated with Dun and Bradstreet; their credit rating can be checked there. Libraries often carry this information.

Shops that haven't paid craftsmen in the past may be listed by craft organizations—especially those which put on wholesale shows. Check them. The ACC keeps a list of this nature and also assists craftsmen in collecting from a derelict shop.

Ask the shop-owner for the name of three other craftsmen he does business

with, and then check with the other craftsmen—this seems to be a widely accepted practice among craftsmen, and it works quite well.

If you have done none of the above, or if you have reason to question a shop's financial dealings, require a deposit when you accept the order, and/or full payment before you ship it. If they reorder, then go to your normal terms of payment.

If you have waited 30 days and haven't been paid, send out a reminder—just a statement (not itemized) and a note saying "balance due . . ." We send them politely but promptly the 31st day.

If you still aren't paid, a phone call or a visit may be in order. By all means, do not ship or deliver any additional work until the previous order is paid for.

. . . You Sell Your Own Work Out of Your Studio?

First of all, check your local ordinances to make sure you are allowed to do this. If you are considered an educational asset, give Brownies free tours, don't put up ugly signs or become a parking nuisance on the street, it will probably be all right.

Second, and very important, set up a system to handle interruptions. One way is to set up "hours" that you are open for business. Ideally, if you can detach your sales gallery from your studio somehow, and then set aside one or two days a month for tours of the studio, at least one of you (if there are two or more of you working in the same studio) can work uninterrupted while the other deals with customers. If you have no hours, you are freer to be away from home at will. But you will also have to be prepared to have customers showing up at will—this can be a real infringement on your privacy. It is more considerate to both you and your customers to specify hours when they are welcome.

. . . You Decide to Set Up Your Own Retail Gallery?

According to Gary Sorenson, it is the rare craftsman who is not bitten by the bug to open his own gallery.* It turns out also to be the rare craftsman who succeeds. Almost everyone underestimates the amount of time it takes to do both the paperwork and the selling in a retail or a consignment shop. If a craftsman has also gotten into a partnership arrangement, it may complicate the matter. Many craftsmen who are poor at business or salesmanship decide to withdraw to their studio after such an experience and leave the selling to someone else.

. . . There is a Craft Center in Your Community?

Fine, it may provide a gallery and a workshop where you can both sell and teach your craft; it may include a craft library as well. Craft centers are increasing rapidly across the country and can serve a valuable purpose. They promote interest in crafts in their community and they may also be able to apply for

*"One Business that Failed," *Artisan Crafts* (July 1973), p. 8.

grants, from their state's Council on the Arts or other agencies, to support their educational programs—this may mean you.

... A Shop Changes Ownership or Goes Out of Business?

Very often the loyalty the original owner has toward you is not transferred to the new owner, whose tastes or personality may be different. As time goes on, the character, both of the shop and of its clientele, may change gradually, and you will have to evaluate whether you want to continue selling to them. It may also happen that they will reevaluate and decide that they no longer want to buy from you. All circumstances are different, but be aware that problems can develop in this situation.

Occasionally a shop you are dealing with goes out of business. If you have sold to it directly (wholesale), you will probably have no problem—except to find a new sales outlet. If you have consigned, they will probably return your work. If bankruptcy proceedings develop, you may have a legal problem when dealing with a consignment shop; in some states your goods may be confiscated as part of the inventory and you may legally be considered a "partner" in the business. Check on this and make sure to protect yourself against it in your written agreement (or stay away from consignment).

It is interesting to observe that almost as many craft shops are going out of business as are opening up in recent years. This means that chances are good that sooner or later you will run into one of the above situations, especially if you are selling to shops that have not yet become established.

OTHER METHODS OF SELLING

House parties, such as the Tupperware-type, can be put on very effectively. In the world of art or craft, it is usually called a "private showing." The main prerequisite to this, whether you invite people to your own studio or someone else has the showing for you, is to keep good lists of your customers. Then once a year, you can mail out invitations to people and have an open house, tour of your studio, and sale of your work. Or you and a few other craftsmen can get together at someone else's house and have a mini craft show for these invited guests.

A friend of ours decided it would be fun to have a "spring fling" one Sunday in May. She asked several of her craftsmen friends to set up a small display, intended for her lakefront lawn but rained out into the house. She sent invitations to 200 friends (ours and hers) who might be interested. It was enjoyable for everyone, and when the crowds had left, we all discovered that we had sold quite a bit of work and made some new contacts besides. If this is continued on a yearly basis, quite a tradition can be built up. It is important, though, to keep good lists of who your interested customers are.

This method of selling is very appropriate to crafts, because it is in keeping

with their personal nature. It is also simple and can be quite rewarding financially.

Mail-order selling is another technique that can be used by craftsmen. You can sell by direct mail, similar to the open house invitation, through ads in magazines or publications; or possibly, through a mail-order company.

If you have an item that is unique, can be clearly described or depicted in a line drawing or photograph, and has an appealing function, you might consider advertising it for sale in a general-interest magazine or a craft publication. Several small repetitive ads are more effective than one large one. Make sure that you charge full retail price, because advertising is costly. Be prepared for a large response—if possible have a follow-up catalog to mail out with the order. State whether you charge extra for shipping and handling, and make sure you offer an item that can be mailed fairly easily.

Some crafts and certain items lend themselves to this better than others. There are many variations on the mail-order theme, which haven't been used too extensively in crafts, but appear to have great potential and a growing interest.

Don't overlook other offbeat ideas. There are markets all around you: pediatricians' offices for children's items such as wall-hangings or toys; doctors', lawyers', and professional offices for decorative items such as sculptures, wall hangings, stabiles, mobiles, planters, etc.; restaurants for centerpieces (or maybe they even have a craft shop attached); florists for things having to do with plants (sometimes they have little gift shops, too).

Many craftsmen near us have been taking their work to the regional farmers market. These open-air markets, so much a part of Europe, are becoming more and more common in this country. They are fun and a good way for shoppers to cut out the middle-man.

Whatever methods you choose to sell your crafts, be confident and be creative. This is necessary for survival.

6 Etcetera, Etcetera, Etcetera

PUBLICITY AND ADVERTISING

If you ask the average craftsman if he advertises, his answer will probably be no. This may be true if one distinguishes between advertising (what one pays for) and publicity (exposure, or free advertising). If he doesn't actually advertise, then, he exposes himself often.

You and the image you convey to other people—your work, how it looks in others' homes or on their person, what people say about you and your work to others, even your atypical life style—these are all forms of publicity, which can be good or bad. Having bad work in somebody's house or having a reputation for being disagreeable is actually negative publicity—no publicity at all would be much better.

Customer satisfaction is the basis for the continued success of any business. The people who decide to buy and then buy again are the life blood of a craftsman. What you try to do is to attract and maintain a clientele of satisfied customers. This may be time-consuming, but it is cumulative over the years, and **72** well worth the effort.

Shows don't constitute paid advertising, but they are good publicity or exposure for both you and your work. Shops that carry your work are also giving you free publicity, especially if your work carries your special tag. Occasionally newspapers or television will give you publicity—you may not think of yourself as newsworthy, but perhaps because of your uniqueness or the timeliness of an upcoming event you will be participating in, a newspaper will do an article or a photo essay on you, or a television station will carry an interview with you and show pictures of your work. You do not need to wait for them to come to you. If someone has done a good photo essay of you and your studio, possibly to be printed as your brochure, a newspaper may take the whole thing as is. People like it if you can do their work for them and justify their using it.

Your photo essay might even be material for the Sunday magazine section. If you should receive this type of publicity, have the article plasticized so you can take it around to shows with you and include it as part of your display.

If you know the people promoting a local craft show, let them know you would be willing to appear on TV to promote the show—this is publicity for both of you.

There may be booklets of tourist attractions in your area in which you could list your studio as open to the public. There are bus tours put on by museums, senior citizen groups, etc. Sometimes it is possible to arrange for them to tour your studio. Some states even put out a booklet of "craft trails," studios open to the public and where they are located.

You can do some speaking before groups in your community. This is good public relations, whether it leads to a direct increase in sales or not. If you have slides to show or if you can bring materials and let your audience work, this also adds interest.

If you can give your talk in your studio along with a tour and demonstration, this is very good publicity and it is actually serving to educate people in your community as to just what is involved in producing your craft.

If you belong to local art groups or other professional organizations, they will often carry your news for you free of charge if you ask them to. These are all types of publicity that are free to the craftsman who takes the time to cultivate them.

As far as paid advertising is concerned, our tags are our only real investment. We mentioned earlier that you might want to have a brochure printed up if you sell primarily through shops, or a catalog if you are really into wholesale or mail-order selling. If there is something that makes you unique—perhaps you are a potter who digs his own clay or uses ancient techniques such as *raku,* or a weaver who raises his own sheep, or a silver craftsman using the lost wax technique, etc.—this adds special interest to you and your work and should be used in your promotional material. Prizes, honors, or awards you have received should also be mentioned.

If you only do one thing, we encourage you to invest in attractive and informative tags for your work, as we have stressed in a previous chapter. Remember, advertising expenses are deductible.

We have considered putting an ad in a paper telling people we would be at a particular show before attending that show—this can even be an invitation-style

ad. (This would be advertising for us and publicity for the show.) Or, if it works the other way around and the show advertises that certain craftsmen will partici- pate, your own ad could be placed (upon request) beside the ad for the show. If you have a black-and-white snapshot to send to the fair committee, they will be more inclined to use you in their advertising campaigns, thus giving you free publicity.

We have also thought about advertising one of our items in a national maga- zine, or even with a friend who puts out a wholesale antique catalog. The problem for the individual craftsman is that it may be difficult to fill the demand once he goes about creating it. Since most of us prefer not to grow or to rely too heavily on apprentices, we have shied away from advertising items that have a potential for too great a response (notably hanging planters). More unique items, such as our hanging carved candle holders or our clocks, might be better, except that they are both difficult to ship. How to determine which items are right for mail-order advertising is a matter of judgment and should be considered carefully.

TEACHING

If you enjoy teaching your craft, you may want to supplement your income by giving lessons or by teaching an occasional workshop or course for a nearby school.

Giving lessons in your studio can be a good change of pace, a source of income, and good additional publicity; it may lead to an increase in sales as well. It could also lead into a separate business—that of supplies and equipment for your craft. But caution is necessary here. It is not difficult to make a full-time business of giving lessons and selling supplies in some crafts. If you do not limit yourself, you can easily become a full-time business person and only an occa- sional craftsman.

Some people have told us that they prefer not to give lessons because they have little patience with beginners, or because they cannot tolerate having others using their studio (which, from experience, we agree can be a problem). Others have told us that they have too much competition already and don't want to show any more people how to do their craft.

If you *are* going to hold classes, when is the best time? At periods when sales are lowest, you have the time to do it and probably need the money the most. Early spring has worked well for us; before Christmas was a mistake.

It is difficult to know how much to charge for lessons, but the considerations are the same as for your wares—the time you put in before, during, and after lessons, and your costs—investment in equipment, cost of extra rent, advertising, etc. Estimate how many students you will have (set a minimum number for a break-even point) and charge enough to cover your costs and your time.

We have run lessons in groups of six, a wheel for each student (which we bought and then resold at the end of the lessons), all materials included, for $5

per two-hour session or $40 for eight weeks. We had an excellent response to a few small ads, and everybody seemed to think the cost was reasonable.

If you do give lessons, you should probably not be trying to fill many orders at the same time. If you can get enough students to make the teaching worthwhile, it can be a full-time activity for a while. We originally tried to work at the same time students were using our wheels, but this wasn't worthwhile time-wise.

If you like children, do not overlook them as students. We have had very good response to our children's classes (age 7 to 11), and they have been enjoyable for us as well.

If there is a school nearby at which you can teach one studio course, or if you can do a two-week or so summer course at a craft school, or even at a summer camp offering crafts for children or adults, you may be able to supplement your income in this way. You wouldn't have to open up your own studio to beginners if you did this, and again, it might be a good change of pace. With the interest in crafts increasing, both in terms of education as well as recreation, this area has great potential.

However, craftsmen do *not* have to teach to survive. Many art students come out of school with training and attitudes that lead them to feel that teaching is the *only* way to make a living. This is not so any more. Artist-craftsmen can make a good living at their craft alone; or, if they so choose, they can supplement it nicely by teaching. Lessons and teaching, however, should be considered a service and a means of promoting understanding of crafts as well as providing an income.

ORGANIZATIONS

THE ROLE OF THE GOVERNMENT AND CRAFTS

The federal government has recently become very active in promoting craft cooperatives, which are nonprofit, regional organizations run much in the same way as farmer cooperatives. (A co-op is actually a fourth legal form of business.) Cooperatives share many of the goals of other craft organizations in that they would like to expand markets, procure supplies inexpensively, and establish "training programs."

The government's interest in crafts has been mainly as a means to rural (and urban) economic development. Their interest in crafts per se has been secondary to their interest in social and economic progress. (In fact, those involved on a local level are economics-oriented people who have little or no craft background.) As one craftsman said to us after having attended two conferences in New York State, "They're on a different trip."

What role the cooperative form of organization will play for crafts is unclear—the potential is certainly there.

One thing that should be mentioned here is that the federal government has been encouraging crafts by providing financial assistance through the National Endowment for the Arts. There is now a full-time professional craftsperson

working with this agency. We mentioned earlier that organizations could provide financing for craftsmen. In fact, in the case of receiving government funds, craftsmen desiring certain grants must apply for them through an organization. Government agencies deal mainly with groups, not with individuals.

One of the disturbing aspects of government involvement is that certain pressures for control are parallel with efforts at assistance. One of the topics of discussion at N.Y. state meetings on craft cooperatives has been that of establishing quality standards. "Other professions have their licensing boards," their reasoning goes, "So why shouldn't craftsmen be approved by a state board and have a stamp to affix to their work?" (a seal of approval, so to speak).

This makes an independent soul's hair rise quickly. We personally do not feel that this is a matter for the government (state, in this case) to be concerned with. In the second place, we wonder if it is even a matter for nongovernmental bodies to become involved in. Setting quality standards for crafts enters the realm of esthetics and personal taste rapidly; it is not as objective as deciding on the competence of a teacher or a doctor. If the whole craft world turned into a giant juried show, we think everyone would suffer.

If, on the other hand, craftsmen adopt their own quality and professional standards and also devote some energy to educating the public as to quality design and workmanship, the marketplace can rightfully determine which craftsmen survive and which do not. This seems preferable to having a small board (politically appointed or not) act as a jury. The best protection of the public is not in censorship, but in education.

THE ROLE OF PROFESSIONAL CRAFT ORGANIZATIONS

A state league, a regional craft guild, even a national council can play an important role in the life of the individual craftsman. If organizations are joined for their service value, not for prestige, they can be very useful. As soon as an artist or craftsman joins a group for the sake of joining, or for prestige, he may tend to rely on the judgment of his peers in that group and cut himself off from the real world. In other words, organizations should not be joined as a comfort or protection to one's ego.

However, most craftsmen err in the opposite direction—that of being independent at all costs. We sympathize with this, but there may be times that survival will depend upon banding together for mutual assistance.

According to Merle Walker, director of the League of New Hampshire Craftsmen, an organization should do three things: provide markets, provide services, and educate.

Providing Markets

Many craft organizations put on one or more retail fairs a year. Some even establish and run permanent retail shops where they sell the work of their members. Organizations now are getting into providing wholesale marketing opportunities for their craftsmen as well. Some have craft fairs for wholesale

buyers only; others may provide wholesale "warehouses" for their members' work, or even wholesale catalogs. These are all valuable markets, and it is easier for a group to provide them than for the individual.

Providing Services

A good organization can provide group insurance policies for its members—and there is a very great need for this service among craftsmen. An organization may also be able to offer financial assistance in the form of a loan or an application for a grant for a particular craftsman. A large organization such as the American Crafts Council can even lobby politically for craftsmen. Craft organizations can also order raw materials in bulk at a lower rate. These are all valuable benefits.

Providing Educational Programs

These can be directed inward—educating craftsmen—or outward—educating the public about crafts.

Many craft organizations put out a newsletter or magazine; some also print bibliographies, lists of craft courses, etc. They may also distribute craft books.

Some put on marketing seminars for craftsmen and shop-owners; some run children's workshops; some may even run their own summer or year-round craft schools. As suggested earlier, an organization might also serve as a clearinghouse for providing information on shows or shops—at the rate these change, though, this is a mammoth project.

Many craft organizations run educational programs for the general public as well as for craftsmen. Demonstrations at fairs, craft series on television, film and lecture presentations to groups are all being undertaken frequently. They all are necessary and worthwhile activities.

Problems

We have recently become aware of a problem that has existed within many craft organizations. Organizations, whether local or national in scope, tend to be composed of two distinct types of craftsman—the part-time craftsman who earns his living teaching or elsewhere, and the professional craftsman. Most full-time craftsmen work long hours in the interest of making ends meet financially. To contribute the necessary time to be an officer or a committee chairman could be a serious financial setback to many professional craftsmen. They are often, therefore, abdicating and leaving the work and responsibility to their part-time colleagues. Unfortunately, their interests and needs can be quite dissimilar. A large craft organization's decision to run a wholesale show in June, when the teachers get out of school, instead of in the early spring, when it would benefit craftsmen and probably shop-owners more, is a case in point.

77 This situation is changing gradually as professional craftsmen become more

numerous and more willing to influence the decisions of organizations. Separate organizations may be in order for each type of craftsman, since their needs and problems are different.

CRAFTS EDUCATION IN COLLEGES AND UNIVERSITIES

Each of us is born with a capacity for growth . . . not just physical growth, but growth of the ability to think, to create works of beauty, to live freely and wondrously and to add to the lives of others.*

The level of education of today's craftsman is very high, in general. Most have college degrees and many have advanced degrees in everything from English Literature to Astrophysics. As suggested in the quote above, there is a certain fullness that comes with this.

If we were to return to an apprenticeship system of educating craftsmen in one skill only, we would be likely to end up with narrow "tradespeople" instead of total people—professionals with a certain amount of depth and awareness. An apprenticeship program, we feel, should be an adjunct to a well-rounded education, not a substitute for it.

This may appear to be a plug for art programs in colleges and universities. It would be, if the schools were preparing their graduates to do something other than teach art. In reality, an art school background may be more of a liability than an asset to the production craftsman, who must develop simple designs which he is willing to perform repetitively. If the schools instituted some courses in business and marketing for craftsmen, as well as philosophy of production, and made available opportunities for apprenticing with master craftsmen for credit (similar to the practice-teaching program), then their "art" programs could be easily adapted to the needs of the artist-craftsman as well as the artist-teacher.

Many universities still seem to feel that this type of education belongs in the two-year technical colleges. If crafts are defined as a trade, this is justifiable reasoning. If, however, a craftsman is a professional person, similar to an engineer or a teacher, his education logically belongs in our colleges and universities. (The word "professional" as currently appled to craftsmen simply means that they earn their living by working full-time at their craft. We have been trying to emphasize that professionalism is also a set of attitudes, similar to those held by a doctor or engineer.)

Although there are few degree programs in professional crafts, there are many courses available to students who are interested in crafts. The American Crafts Council puts out a list, updated each year, which is divided into craft courses available during the year and summer craft courses. This can be obtained for a fee from the American Crafts Council (see Bibliography).

Even if colleges do get into the education of the professional craftsman, there will still be a need for craft organizations to implement these with workshops and apprenticeship programs. Many people who have already obtained a college

*Quoted from Adlai Stevenson, *Artisan Crafts* (July 1973), p. 14.

79

education need specific training in one craft or another, or desire a broader general knowledge of crafts.

Neither colleges nor organizations can fill their role as educators of craftsmen without the help of the studio craftsman, who must be willing to take on apprentices and act in the capacity of master craftsman. The craftsman must see himself, to a degree, as an educator, both of the general public and of future craftsmen.

7 Survival

Although most books on business tend to talk about success and reasons for the success or failure of small businesses, we have chosen to set *survival* as our goal. Success has come to mean making a lot of money. Survival, to us, means making enough money to pay your bills and enjoy life while maintaining values that are important to you—"a life as well as a living."

Survival, it seems to us, is a matter of attitude—not of prior business or craft skills. If you have confidence in yourself, if you are willing to meet people halfway, if you can recognize when you need the help of others, chances are you will survive.

One potter said to us recently, "I didn't know anything about business when I started, but I discovered I had to create some rules just so I could keep throwing pots." Or to paraphrase Voltaire, "If business principles didn't exist, we would have to invent them." Many craftsmen, actually, are very successful at developing their own set of business procedures. They are surviving nicely. Many, however, are not capable or inclined in this direction. It is these people that we hope to reach with this "Survival Manual."

Often craftsmen who have left an establishment-job or who have never had one think of themselves as having "dropped out." Friends of ours refuse to fill

wholesale orders because they have to work harder and produce more items for

the same amount of money—if they wanted to work that hard they could get a job back. The truth of the matter is, however, that while dropping *out,* we have all dropped *in* to something else, which may be more rewarding, but is hardly less work.

But there is such a market for crafts at this point, that there is a danger in succeeding (in making money) too easily and too soon. To develop your craft into something really substantial takes time and effort, and it will only happen over a period of years.

TRENDS

It has probably occurred to all of us that something could happen tomorrow to burst the craft bubble, so to speak. Could problems with the national economy or faddishness on the part of the public put us out of business? This is possible, but not probable. People need what we seem to have less and less of—individualism and beauty—in their lives. Crafts are filling a definite need, not as high on Maslow's scale as food and shelter, but coming shortly thereafter—this need involves self-esteem, the respect of others, and even esthetics. (This need partially explains the parallel vogue for antiques.)

There are other trends right now which seem conducive to the craft market. One is interest in the environment. This has influenced people to consume less in quantity and buy quality items which will last longer. (The environmentally concerned customer will buy a set of dinnerware, even though he could be using paper plates.) It has made people more aware of the merits of doing things by hand and using less power. More specifically, it has increased the market for items which have to do with plants and candles. (We could easily make a living from hanging planters and candle holders.)

Another favorable trend is the increase in leisure time. This is coupled with the Puritan ethic of productive leisure time—doing nothing is laziness, but relaxing by learning a craft for enjoyment is commendable. Many craftsmen who have difficulty surviving from their craft alone can turn to the recreational and educational side of crafts to supplement their incomes.

Recently, the home has replaced the automobile as the major status symbol. This is also beneficial to craftsmen. It seems that the more similar homes appear on the outside, the more money people will spend to give them character and individuality on the inside. In the same vein, people will spend a good deal of money on things they wear—clothing, jewelry, etc.

Trends do change with distance and time. In this country, West Coast crafts have a different flavor than East Coast crafts. The East Coast seems more rooted in tradition—nineteenth-century functional craftsmen, such as blacksmiths and tinsmiths, have evolved into twentieth-century artist-craftsmen; whereas the West Coast seems freer of this cultural tradition and is more involved in crafts as an art form, experimenting more with media and materials. The Midwest, in the center, seems to be transitional and to evidence both influences. If this is an oversimplification, it can at least be said that the types of crafts being done, as

well as the preferences of the craft-consumer, seem to change somewhat from region to region.

In a media-oriented society, trends change rapidly. Craftsmen must be prepared to evolve gradually themselves to survive. The advantage that craftsmen have over industry is that they can change a design overnight and start producing it immediately. (One way of protecting uniqueness of design is, in fact, by changing this design; this is an easier method than obtaining a copyright or a patent.)

Saying that craftsmen should be aware of changing trends is not to say that they should compromise their standards because of the market, only that some trends may work in their favor if they attempt to take advantage of them.

THREATS

If general trends seem to be encouraging, what threats exist to the survival of crafts as a way of life? Our biggest problems may come from within, although some do exist from without. Here are a few threats that are worth giving some thought to:

OVERORGANIZATION. People who are eager to create a centralized distribution system for crafts are well-meaning, but, we think, misguided. Part of the appeal of crafts is that people have to exert some effort to find them; but ferreting out a good craft shop or show or studio is much more rewarding than going to your nearest shopping center and knowing you can buy whatever you want. Somehow, antiques and marijuana are available to those who want them without the government or business setting up a centralized distribution system. The whole thing would become so impersonal and homogenized as to become meaningless. We would also run the risk with crafts that the small subsistence farmers succumbed to with the advent of mechanized farming and agribusiness.

POOR-QUALITY CRAFTS. If the image of crafts becomes one of junk instead of one of superior quality, all craftsmen, good or bad, will suffer. There are craftsmen who will justify selling anything because they can support their life styles in this way, regardless of the effect of their work on others. There are also craftsmen who justify poor-quality workmanship in the name of art, free expression, etc.

UNBUSINESSLIKE PRACTICES. Also threatening to the craft world are those who do not fill orders on time, fail to keep track of money or pay taxes—in general are unprofessional. Shop-owners say that lack of reliability and lack of supply of quality crafts are the two greatest problems they face in dealing with craftsmen. Shops need to order in some kind of volume and to know that they can reorder. They may be forced to turn to mass-produced crafts which they can order from a catalog, poorer-quality crafts, imports, or other substitutes if quality crafts are not available to fill the demand. It is up to the craftsman to adopt professional attitudes, be businesslike to the greatest extent possible, and to see

that high-quality crafts be made available to the shops and to the public in a realistic manner.

OVEREXPOSURE. If crafts are constantly before the public or exploited by the media, people will become as numb to them as they seem to have become to peace, ecology, and drugs. Abuse of the label "handcrafted" is also a problem—this label seems already to have been so overused as to have become meaningless.

INDUSTRY. This can become a threat to certain crafts, if similar products can be manufactured at a significantly lower price. The market for candles seems to have been harmed in this respect. The general public may not pay more for something just because it is hand-made. Uniqueness, originality, and excellent design are good protection against the encroachment of industry. Constant evolution is another.

THE DO-IT-YOURSELF TREND. This can be harmful to simple crafts; that is, those which are available in kit form, or those which do not involve great investments of money (candle-making, leather, macrame, etc.). But again, uniqueness and superior-quality work help protect against extinction. At any rate, there will always be those who do not have the time or interest in doing something with their hands.

With all these threats, good craftsmanship and professional attitudes help insure survival, which is neither a fixed nor a quantitative concept. It is a process that is always relative and always in flux. It has to do with the total quality of life—not of a business or of a craft, but of the whole person. It is an attitude of becoming, not a state of being.

Bibliography

We have found the following books, pamphlets, and periodicals valuable tools.

BOOKS ON MARKETING CRAFTS

Nelson, Norbert N., *Selling Your Crafts, New York:* Van Nostrand Rheinhold, 1967. (Paperback) Mainly of interest to large-scale, craft-industry craftsmen—such topics as "recruiting a wholesale sales force," etc. A little heavy for the studio craftsman with no technical business background. Chapter on running a retail store and legal pointers are of interest.

Wood, Jane, *Selling What you Make,* Baltimore, Md.: Penguin, 1973. (Paperback) Handwritten with much counterculture philosophy. Some information on selling, especially to department stores.

BOOKS WITH SECTIONS ON MARKETING CRAFTS OR ART

Associated Coucil on the Arts. *The Visual Arts and the Law,* New York: concerns the artist and his gallery, his publisher, studio sales, commissioned works, and tax problems.

Counts, Charles, *Pottery Workshop,* New York: Macmillan, 1973. A good photo manual for potters; includes a chapter on marketing.

Gibson, Mary Bass, *"Book of Careers at Home," Family Circle Magazine.* This is oriented to the hobby craftsman, with information on where to find markets, advertising, pricing, etc.

Goodman, Calvin J. *Marketing Art—A Handbook for Artists and Art Dealers.* Los Angeles: Gee Tee Bee, 1972. Not very helpful for the production craftsman; of possible value to the artist-craftsman exhibiting in galleries.

Harris, Kenneth. *How to Make a Living as a Painter.* New York: Watson-Guptill, 1970. Excellent on the philosophy of selling art to the public. Good pointers on pricing; also on the effect of art organizations on an artist. Very relevant to the craftsman.

Isenberg, Anita and Seymour. *How to Work in Stained Glass.* Philadelphia: Chilton, 1972. Two good chapters on selling at shows and through shops. Very helpful, especially to craftsmen in stained glass.

GENERAL BUSINESS AND MARKETING BOOKS

Baumback, Clifford, Kenneth Lawyer, and Pearce C. Kelly. *How to Organize and Operate a Small Business,* 5th ed. Englewood Cliffs, N.J.: Prentice-Hall, Inc., 1973. Technical but accurate. Chapter 24 on regulations and taxes and Chapter 25 on simplified record systems were quite helpful to us.

Still, Richard R., and Edward W. Cundiff. *Essentials of Marketing,* 2nd ed. (Paperback) Englewood Cliffs, N.J.: Prentice-Hall, Inc., 1972. Contains a very interesting chapter on buyer behavior; also one on pricing.

BOOKLETS

Bank of America. "The Handcraft Business," *Small Business Reporter,* San Francisco: 1972. The most concise (16 pp.) summary of crafts as a business; covers your own retail store, art shows and craft fairs, wholesaling, consign-

ment, financial assistance, legal forms of business, taxes, advertising, growth, etc. Also lists other publications of the *Small Business Reporter.* Extremely helpful, very readable, written in common-sense language.

Counts, Charles. *Encouraging American Craftsmen.* Washington, D.C.: U.S. Government Printing Office, No. 3600-0010, 1972. A report for the government, written by a potter, with useful information on government involvement in crafts, especially in terms of rural economic development; very good bibliography.

Eastman Kodak Co. *Basic Principles of Business Management for the Small Photographic Studio.* Rochester, N.Y.: Kodak Publication No 0-1., 1968. Good for studio photographers; some concepts, such as costing, applicable to all crafts.

Nicholas Picchione. *Dome Simplified Monthly Bookkeeping Record.* C.P.A. Providence, R.I.: Dome, 1973. This series is very simple, and very usable for craftsmen—recommended by many.

BROCHURES, PAMPHLETS, NEWSLETTERS, AND CALENDARS

AMERICAN CRAFTS COUNCIL PUBLICATIONS

"Mail Order Form: Publications by the American Crafts Council." ACC Publication Department, 44 West 53rd St., N.Y. 10019. This lists publications available from them and gives the cost for members and nonmembers.

Some of the publications we found helpful were:

Directory of Craft Courses, 1973-74. 16pp. "A listing of universities, colleges, junior colleges, private workshops, museum schools and art centers and the craft courses and degrees they offer; compiled annually by the Research & Education Department."

Packing/Shipping of Crafts, 1973. 22 pp. General and specific recommendations for various media; lists of supplies, shipping agents; export information, bibliography.

Reference Bibliographies (in Clay, Enamel, Glass, and Wood).

INTERNAL REVENUE SERVICE PUBLICATIONS

"Mr. Businessman's Kit." Free from your local IRS Office.

Tax Guide for Small Business. Yearly edition publication 334 of the IRS.

PUBLICATIONS AVAILABLE THROUGH
THE SMALL BUSINESS ADMINISTRATION

Bibliography, *Handcrafts and Home Businesses.* S.B.A., February 1971. Many pamphlets are available from your nearest S.B.A. office at little cost. These also include an interesting one on managing a consignment shop.

PUBLICATIONS ON COOPERATIVES

Most information on cooperatives comes from the United States Department of Agriculture's Farmer Cooperative Service. Dick Seymour is the craft specialist for this department, and his two publications are very informative:

Program Aid #1001, *The Cooperative Approach to Crafts,* by William R. Seymour. Also includes a list of other publications on co-ops available through this agency.

Program Aid #1026, American Crafts, *A Rich Heritage and a Rich Future,* by William R. Seymour.

Shop the Other America. Boston: New World Coalition, 1972. A very interesting mail-order catalog for crafts made in urban and rural cooperatives, prepared by Community Development Corporations.

OTHER PUBLICATIONS

Massachusetts Department of Commerce and Development. "Marketing your Handcraft." Boston, Mass. Good, short analysis of determining costs and setting prices for your work.

National Endowment for the Arts. *Visual Arts Program Guidelines,* Washington, D.C., 1973. Information on applications for grants.

Niles, Henry. *National Calendar of Indoor/Outdoor Art Fairs.* Fort Wayne, Indiana, published quarterly. Very useful if you are doing shows regularly or would like to plan a show circuit in another area of the country. Also contains information on professional shows.

Norris, Robert B. *Let's Have a Craft Show.* Connecticut Guild of Craftsmen, Inc., Storrs, Conn. Small booklet with useful information if you are considering putting on a craft show.

The Society of Connecticut Craftsmen, Inc. The Handbook for Craftsmen. Avon, Conn., 1973.

PERIODICALS FOR CRAFTSMEN (GENERAL)

Artisan Crafts, Ed. Barbara and Harry Brabec, Box 179M, Reeds Spring, Mo. This is very useful to the professional craftsman. Every issue contains some

marketing information as well as columns on specific crafts. Directories are also published listing craftsmen who want to sell, shop-owners who wish to buy crafts, craft suppliers, craft books, and periodicals. Good for shop-owners and suppliers as well as craftsmen. Very friendly and cooperative editors who are willing to check back in their files to help you track down information.

The Craftsman's Gallery, Box 645, Rockville, Md. A magazine which provides outlets for craftsmen who want to sell their work through pictures in the magazine—good if you're thinking of getting into mail-order business.

Craft Horizons. 44 W. 53rd St., N.Y. 10019, Received through membership in the American Crafts Council, as is their newsletter "Outlook." Mainly useful to the artist-craftsman or teacher-craftsman who is one-man show oriented; occasional articles which are useful to the professional production craftsman.

Craft/Midwest. Box 42, Northbook, Ill. Very helpful for producing craftsmen in the Midwest. An excellent marketing column written by Michael Higgins, glass craftsman and marketing expert.

Westart. 103 High St., Auburn, Ca. Concerns crafts on the West Coast.

Periodicals for specific crafts can be found by looking through many of these general craft periodicals or through the art index of the *Readers Guide to Periodical Literature* in your library.

Index